Bird Migration

THE INCREDIBLE JOURNEYS OF NORTH AMERICAN BIRDS

BY STAN TEKIELA

Adventure Publications
Cambridge, Minnesota

DEDICATION

To Finka

ACKNOWLEDGMENTS

Many thanks to my good friends and associates who help me in the pursuit of finding and photographing birds: Agnieszka Bacal, Roberta Cvetnic, Ron Green, Frank Taylor and Jim Zipp.

And to all the organizations that work tirelessly to preserve wildlife—especially birds—and to educate people about wildlife conservation: Hawk Ridge Bird Observatory, Operation Migration, National Park Service, National Wildlife Refuge System and United States Fish and Wildlife Service.

Special thanks to Rick Bowers, wildlife biologist and extraordinary friend, for reviewing this book. I am continually impressed and amazed at your in-depth knowledge of birds.

All photos by Stan Tekiela except pg. 100 by Rick and Nora Bowers

Edited by Sandy Livoti

Cover and book design and illustrations on pp. 55 and 61 by Jonathan Norberg

Graphic art on pp. 13, 14, 19, 25, 43, 45, 49, 53, 57, 65, 67, 75, 76, 80, 85, 87, 89, 91, 95, 99, 101 and 106 derived from Shutterstock stock photography

Bird Migration: The Incredible Journeys of North American Birds
Published by Adventure Publications
An imprint of AdventureKEEN
330 Garfield Street South
Cambridge, Minnesota 55008
(800) 678-7006
www.adventurepublications.net
Printed in China
ISBN 978-1-59193-814-9 (pbk.)

TABLE OF CONTENTS

THE MYSTERY OF MIGRATION

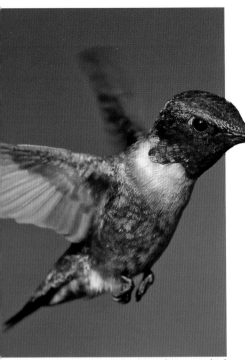

Ruby-throated Hummingbird

All around us, nature is full of wonder and mystery, and migration illustrates this well. It's an amazing natural occurrence that seems simple enough. Birds leave the northern regions in the fall, before the onset of winter. They spend the coldest months farther south, and then return in the spring. But while this may sound easy, it's not the whole story. Migration is one of the most difficult and dangerous things that birds can do.

Migration is basic and yet extremely complex. Avian biologists and naturalists have learned a lot about it, but even with our advanced technology, there are still many aspects that are not fully understood. For example, how does a young bird that just recently hatched know when it's time to migrate? How does it know where to go? How does it find its way, and how does it know it's in the right place when it arrives? These are just some of the basic questions that have baffled researchers for centuries.

The ability to migrate is even more mind-boggling when you think about what humans need to do to navigate a long trip. Imagine if you had to navigate to a destination near the tropics, but you had no access to weather reports, GPS, or even such basic amenities as a highway system or a car. How well do you think you'd do? Let's face it, you wouldn't make it. On the other hand, birds have excellent built-in systems to help them prepare for migration and navigate during their trip.

People have held strange ideas about where birds go and what they do during winter. Long ago, many believed the notion that some birds buried themselves in mud at the bottom of ponds and lakes for the winter, and then returned to the surface in the spring. Of course, we know today that this is biologically and physically impossible.

People also thought that Ruby-throated Hummingbirds could not fly far away to escape winter, so they hitched rides on the backs of larger migrators, such as Canada Geese. Today, we know that Ruby-throats migrate to the tropics of Central America, crossing over the Gulf of Mexico in a rigorous, 25-hour nonstop flight of more than 600 miles. For the most part, Canada Geese don't migrate that far, flying less than 500 miles in total for their migration.

Even now, some folks mistakenly think that after birds mate and raise babies in the north, they migrate south and mate again, but this is not true for any bird species. When birds fly south for the winter, they just rest. They won't nest until they return to their breeding habitats in such places as our parks and backyards.

Lots of birds, such as warblers and orioles, migrate great distances. Others go only as far as needed to survive the winter. And, of course, some birds don't migrate at all. Black-capped Chickadees, White-breasted Nuthatches and Northern Cardinals stay put all year and endure the entire winter, no matter how harsh it becomes.

While the behaviors and overall mechanics of migration are still being explored, in this book, I will present what is currently known about bird migration and bring out its mysteries. Using the latest information, along with maps, illustrations and many colorful images of the migratory birds that we love, I will open the door to migration so that you too can marvel at its miracles, just as I do.

Enjoy the Migrating Birds!

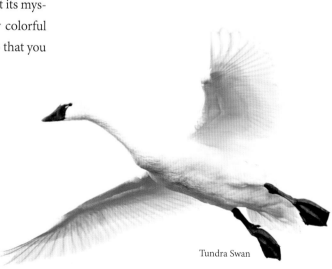

Tundra Swan

5

Mallard and Sandhill Crane

MIGRATION:
THE GENESIS

Most everything in nature is tied to the driving forces of the need to feed and the need to breed. Migration is nature's way for birds to take advantage of new opportunities, whether it's a prime nesting area in their summertime habitat or abundant food. When migration first began, some species would have adapted to different habitats and flourished, while others would have perished through natural selection.

We don't know exactly when migration started, but we do have some good theories to help explain the phenomenon. Avian migration evolved over millions of years. Migration allowed birds to expand their range into other areas where there was abundant food, suitable breeding habitats, and no competing birds. When birds moved farther north and discovered untapped provisions and places to nest, the offspring of these explorers most likely continued the habit.

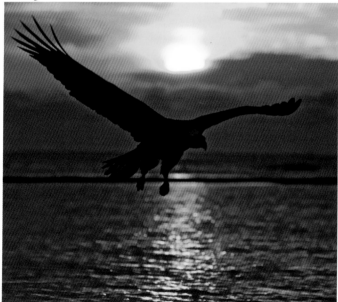
Bald Eagle

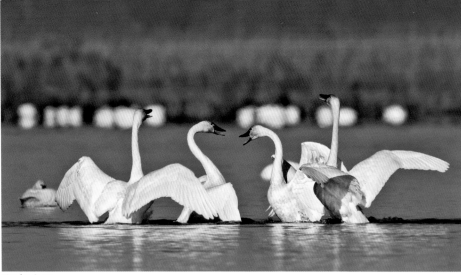
Tundra Swan

Our planet has changed a lot over the last few million years. Over the past 2.5 million years, North America was greatly influenced by many cycles of advancing and retreating glaciers. The most recent glacial event ended 10,000–15,000 years ago. At that time, the massive ice sheets that covered much of the land were retreating. In many locations, the glaciers were upwards of a mile thick! This means that more than 5,000 feet of ice covered the terrain. The movement of these glaciers had the power to grind down towering mountains into rolling hills and flat plains.

During this time, birds would have stayed well south of the ice fields. Migration might have been just a short trip to find more food and perhaps new territories for nesting where other birds were absent.

As the glaciers receded, more land became available and offered more opportunities for birds. Keep in mind that this was not a one-time event. This kind of epic event happened many times, giving birds many chances to refine their migratory behavior over and over again. Each time, the birds responded and modified their movements to match the changing climate and available resources.

A WINNING STRATEGY FOR SURVIVAL

Migratory biologists look at the act of migration in terms of a simple cost-benefit ratio. If the cost of migrating were more than the benefit, migration would not have evolved. There's no doubt that the benefits must have outweighed the costs, because around the world we now have billions of birds migrating biannually.

The largest concentration of bird species occurs in the tropics around the equatorial belt. Thousands of bird species are crowded into this region, creating a lot of competition for food and mates. While the tropics offer abundant food and nesting resources, the option of migration brings some relief to the crowded conditions.

At least 4,000 species of birds migrate today. This represents a staggering 40 percent of all bird species. In North America, about 350 different species migrate. Clearly, migration is a winning strategy for survival.

Even now, the birds that return first in the spring claim the best territories with the best sources of food. These birds are the most successful at reproducing. Male migrators tend to arrive at the breeding grounds before the females. With ample food, the males will produce healthy-looking feathers to advertise their prowess and attract the best females.

When available food diminishes and the weather changes, the breeding season ends and birds return to their wintering (non-breeding) grounds. These migratory birds don't breed during winter, so there's no reason to claim territories and attract mates. Unlike the breeding season, when fighting for territory is the norm, birds generally coexist very well during the winter months.

Mallard

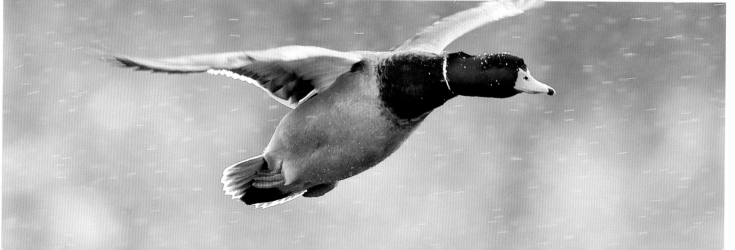

NOT ALL MIGRATION IS THE SAME

There are a lot of misconceptions about migration. Too often, migration is thought of as just one kind of movement from north to south or south to north. Well, the truth is, there are many different ways to migrate. There are at least four well-defined types of migration that are generally accepted in the avian world. They are complete migration, partial migration, irruptive migration and non-migration. Some birds are also nomadic in nature and defy the migration rules.

Scarlet Tanager

Blackburnian Warbler

COMPLETE MIGRATORS— BIRDS YOU CAN COUNT ON

Complete migration is perhaps the most well-known type of migration, and I believe it is the specific type of migration that most people think of when considering migration. Complete migration is just like the name implies. In a population of complete migrators, generally all of the birds move hundreds, or even thousands, of miles between summer and winter locations at predictable times each year. We can often predict with fairly good accuracy when individual species of complete migrators will leave in the fall and return to their breeding grounds during spring.

Furthermore, normally all of these complete migrators will migrate on schedule. When an individual fails to migrate, it either has a genetic defect or it is sick. A bird such as this will perish in its home range during the winter.

Warblers and tanagers are complete migrators, and they fly some of the longest distances of any migrator. They are called Neotropical migratory birds because they migrate in the fall from northern states and Canada to spend the winter in the tropics of Central and South America. In the spring, they make the long journey back to the north, where they nest and reproduce.

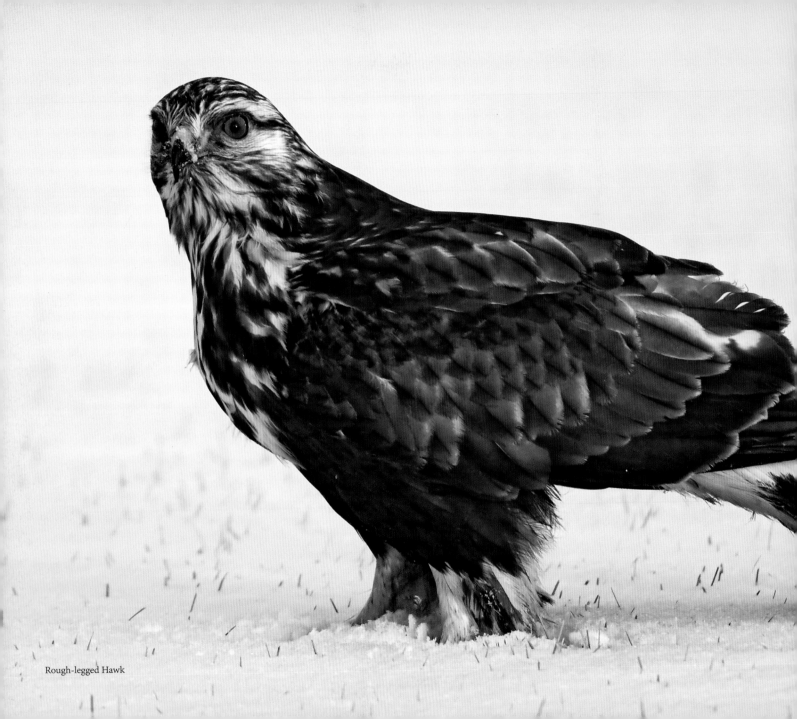

Rough-legged Hawk

Birds don't have to fly all the way to the tropics to be complete migrators. Rough-legged Hawks, for example, nest in the northern regions of Alaska and Canada during summer. When winter approaches, the population moves south to the Lower 48, where it remains for the winter. Some of their wintering grounds can hardly be called warm. In fact, many of these hawks stay in Montana and North Dakota. This migration is still considered complete because it occurs regularly every year and extends over many hundreds of miles.

BREEDING AND WINTERING GROUNDS

Arctic Circle

Pacific Ocean

Atlantic Ocean

Summer / Winter

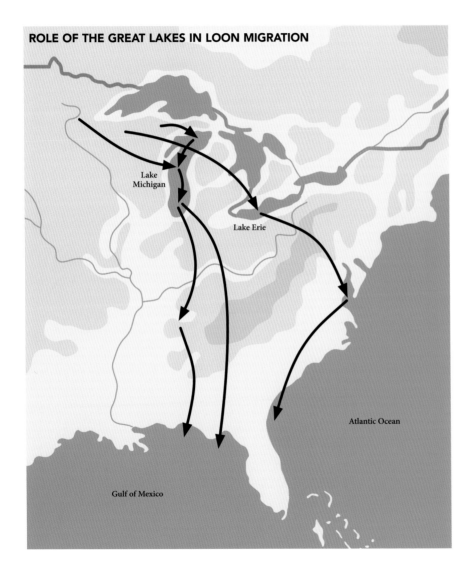

ROLE OF THE GREAT LAKES IN LOON MIGRATION

Lake Michigan

Lake Erie

Atlantic Ocean

Gulf of Mexico

Common Loons are another good example of complete migrators, but they don't migrate to destinations on land—they winter in coastal waters instead. Come spring, they return to their homes in the North to mate and nest.

We often think of complete migration as a straight line north to south and vice versa. But some birds, including Common Loons, take a zigzag route during migration, especially during the fall. The Great Lakes play a very important role in loon migration. Many of these birds leave the lakes of Minnesota and Wisconsin and fly east to Lake Michigan, where they may stay upwards of a couple of weeks. There, they feed and swim, heading down the lake toward Chicago. When they approach land, they take flight and continue their journey south to the Gulf of Mexico. Other loons make a similar stopover at Lake Erie before continuing on to the Atlantic Coast.

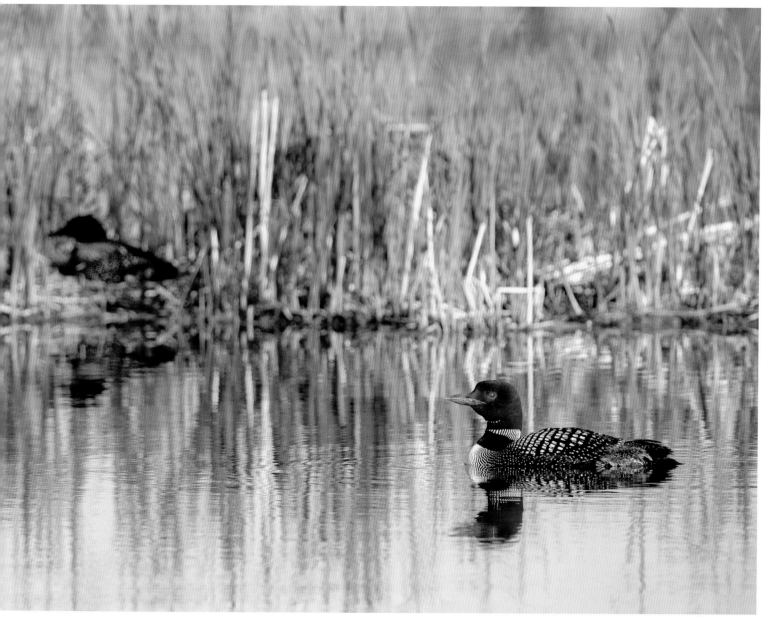

Common Loon

Other bird species migrate directly east and west. The Varied Thrush, a colorful, robin-like bird, often leaves its home in the Pacific Northwest and migrates east, often wintering in the Midwest. Not all Varied Thrushes do this, but enough make the trip to consider it a regular occurrence.

Still other birds have a complete migration that is vertical. The Dusky Grouse, a chicken-like bird in the Rocky Mountains region, migrates up and down the mountains. During spring it moves down to the breeding grounds, which are at low elevations. In the fall it moves up into the mountains, to the coniferous forests at high elevations. This regular movement, representing up to thousands of feet of elevation change, is also regarded as complete migration.

Varied Thrush

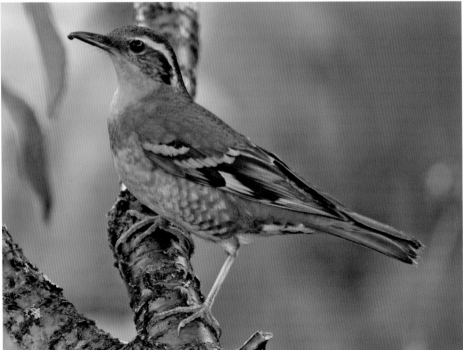

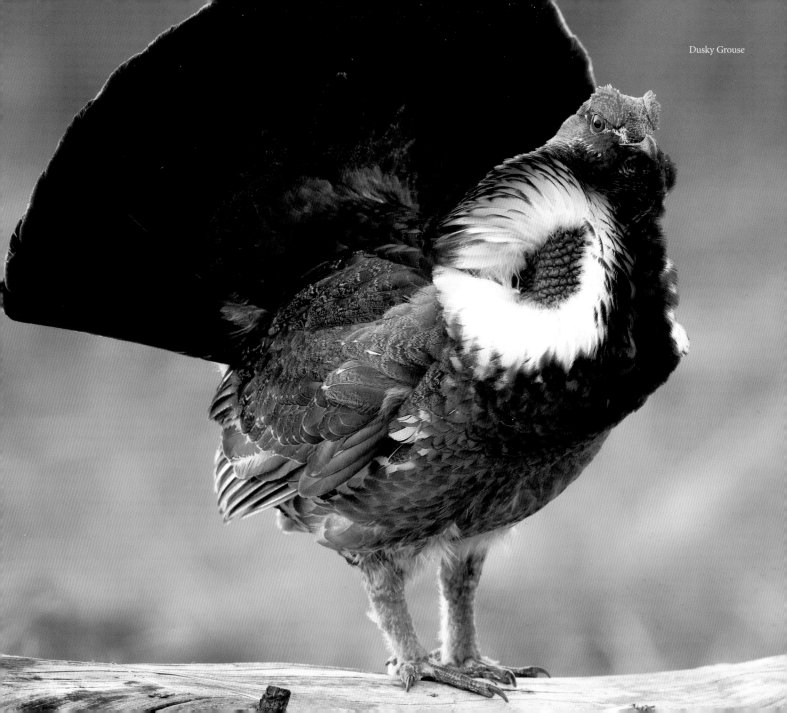

Dusky Grouse

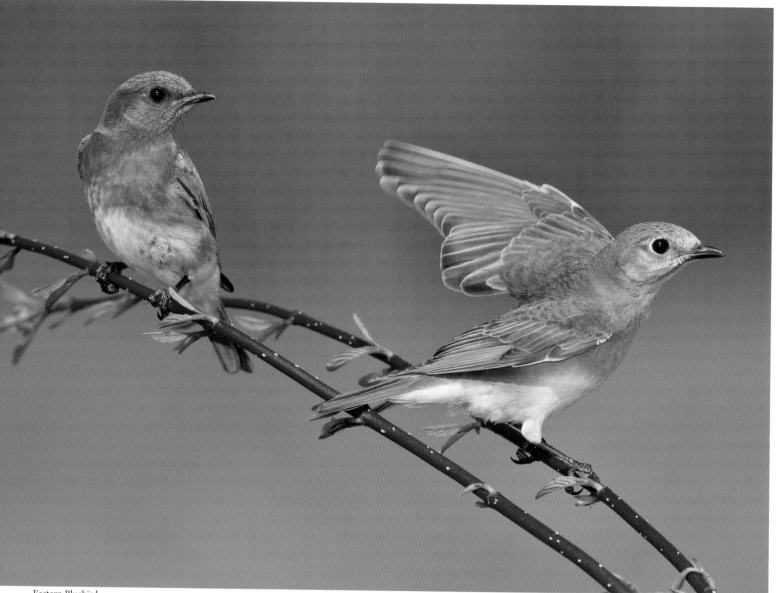

Eastern Bluebird

SHORT-DISTANCE MIGRATORS

In terms of time, you can think of partial migration as a shorter version of complete migration. Many people mistakenly think that common birds, such as American Robins and Eastern Bluebirds, are complete migrators, leaving and returning at set times during fall and spring. But actually, robins and bluebirds are partial migrators, often waiting until the weather turns cold and food sources dwindle before they leave for warmer places. These birds are usually still hanging around in northern states until late November, and a small percentage of the population doesn't migrate at all. They are unlike complete migrators, which leave at a predictable time in the fall.

Partial migration is also shorter than complete migration in terms of distance. Partial migrators fly only a part of the long distances that hummingbirds and other Neotropical birds cover biannually. Usually partial migrators move only far enough south to find a reliable food supply, where they can survive the winter. This is often only a couple hundred miles, but sometimes they will migrate up to 500 miles. Because partial migration is dependent on weather and available food, it is also known as seasonal movement.

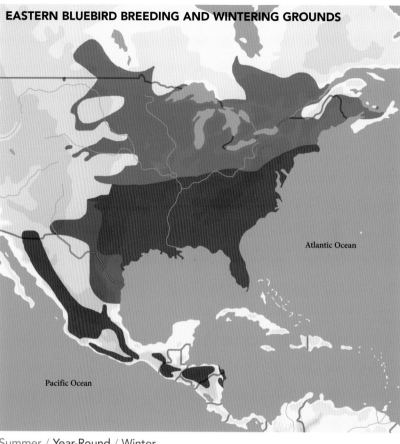

EASTERN BLUEBIRD BREEDING AND WINTERING GROUNDS

Atlantic Ocean

Pacific Ocean

Summer / Year-Round / Winter

The scientific name of the American Robin, *Turdus migratorius*, indicates that the species is migratory, but this is not entirely true. Most studies estimate that about 10 percent of robin populations do not migrate. Instead, these individuals just move to nearby areas with good vegetative cover and a decent food supply, where they tough out the winter. The real challenge for them is finding enough water to drink. During winter, they will gather at any open water they can find.

American Robin

Red-tailed Hawk

Red-tailed Hawk

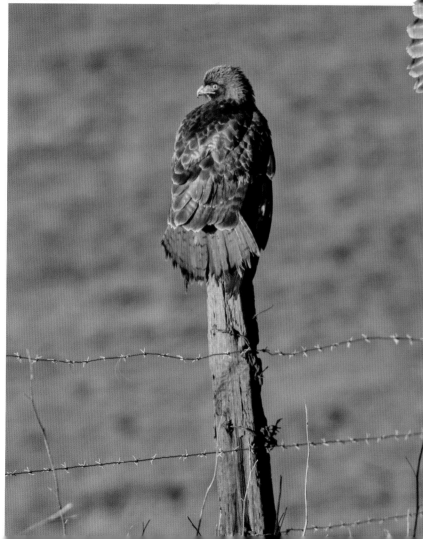

Red-tailed Hawks are also partial migrators. These large raptors migrate only as far as needed, depending on the severity of the winter. Like robins, not all of the Red-tails move south during winter.

The House Finch, which is native to states like California and Arizona, has a fascinating story of partial migration. In the early 1900s, House Finches were captured in the American Southwest and taken to New York City. There, they were dubbed "Hollywood Finches" due to the males' red plumage and pleasing song, and sold as pet birds. Later, laws were passed to prohibit the possession of finches, and the birds were released into the city.

Originally it was believed that House Finches didn't migrate, but by the 1960–70s, studies of banded finches showed that some of the eastern birds were moving south and west for the winter. By the 1980s, it was common to see House Finches moving out of northern states and spending the winter in warmer places. As the years went on, House Finches colonized most of the East and the Midwest. Today, they are considered partial migrators.

Interestingly, the sellers of the finches had unwittingly set up a scenario that eventually forced the birds to react to changing climates. Within a span of just over a century, the movements of House Finches shows how quickly migration can evolve.

House Finch

UNPREDICTABLE MIGRATORS

There are no steadfast rules in nature that apply to all circumstances, and variations are everywhere. This is where irruptive migration comes in. Irruptive migration doesn't follow any rules or common logic.

Irruptive migration is an interesting behavior that's sometimes attributable to food shortages and other times to food abundance. It occurs mainly in northern birds, such as Snowy Owls and Great Gray Owls, and in smaller birds, such as Bohemian Waxwings, Pine Siskins and Red-breasted Nuthatches. These typically northern birds move out of their home ranges and disperse in nearly any direction, not necessarily north to south, when food is scarce or abundant.

Red-breasted Nuthatch

Great Gray Owl

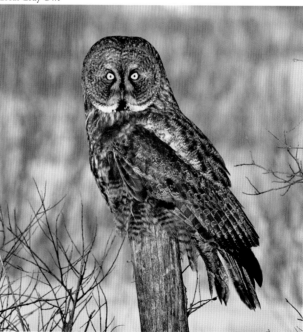

Red Crossbills are a good example of irruptive migrators that move due to food shortages. They have a highly specialized, crossed bill that makes it easy to extract seeds from a pinecone. If a cone crop is meager in the boreal forest during a given year, some of the crossbills will move south to find a reliable food source.

Red Crossbill

IRRUPTIVE MIGRATOR

Pacific Ocean

Atlantic Ocean

Arctic Circle

Year-Round / Winter

Equator

In some species, such as the Snowy Owl, it has been suggested that an abundance of food leads to increased reproduction with an excess of young. Whenever this happens, some owls will irrupt out of their normal range and scatter in many directions. When Snowy Owls irrupt, they will often spread out across a wide geographic region. There are some areas where irruptive Snowies show up more or less reliably, but in general, they disperse far and wide.

Extensive studies of some 800 Snowy Owl skins collected by museums revealed that it was the immature males that migrated the farthest south for the winter, while the adult females stayed the farthest north. So in the years when Snowy Owl reproduction is exceptionally good, it will typically be the young males irrupting outside of their normal range to head south. These are the owls that will be attracting the attention of bird watchers and photographers alike.

Great Gray Owls don't irrupt as often as Snowy Owls, but every now and then a big movement of these birds happens. The last time a really large irruption of Great Grays occurred was during the winter of 2004–05, when hundreds of these owls showed up in northern Minnesota. The first individuals were noticed in late October. By December there were hundreds of these amazing birds. The irruption continued until March, when one by one they moved back north and weren't seen again.

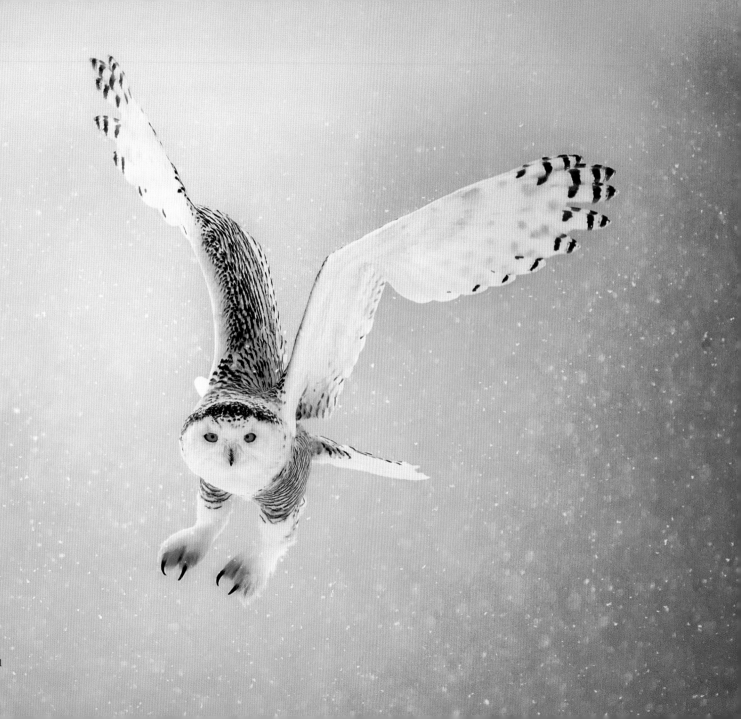

Snowy Owl

It is difficult to predict when an irruptive species might move. Many of these species exhibit an irruptive migration every 5–10 years, but this estimate is only fairly reliable. For 30 years, I have been watching the irruptive behavior of Northern Goshawks, which are said to irrupt every 10 years. During my first two 10-year periods, there was a dramatic uptick in goshawks during the fall migration. On the thirtieth year, no goshawks migrated, proving that irruption is an irregular behavior.

Northern Goshawk

BIRDS THAT STAY PUT

Over time, many species of birds adapted to seasonal changes, surviving the lean times and inclement weather where they lived. Today, we call these species non-migrators. The specialized physical traits that help these birds to stay alive in extreme weather are not found in species that migrate.

Warmth from feathers is crucial during winter, so the more feathers, the better. In preparation for the coming cold, non-migrators grow two-thirds more feathers during the fall molt than migrators. The Black-capped Chickadee, for example, normally has about 1,500 feathers during summer and 2,500 feathers during winter, which is an increase of 67 percent. The extra 1,000 feathers are mostly the small, downy type of feathers that provide insulation under the larger feathers, so you won't notice the difference in these birds at all.

In addition to extra feathers, birds will have a thin layer of extra fat to help keep them warm. Fat is not something that birds can overdo because too much weight would render them flightless.

Huddling also helps non-migrators to stay warm. During cold nights, small non-migrators, such as the White-breasted Nuthatch, will take refuge from the wind and hide from predators in a place of shelter, such as a natural cavity or man-made structure. Sometimes several individuals of the same species huddle in a shelter and share body heat. Other times mixed species pack into a small cavity to keep warm.

In order for birds to remain warm, they shiver their muscles, which produces body heat. Mammals, such as humans, only shiver as a last resort to stay warm. Birds, on the other hand, shiver all the time during cold weather to generate heat. It is a completely different way of keeping warm (thermal regulating).

White-breasted Nuthatch

Another important winter survival strategy for non-migratory birds is torpor. Not to be confused with hibernation, torpor is a short-term, temporary slowing of the metabolic, respiratory and cardiac systems, and it involves lowering of the body's core temperature. Here's how it works:

During cold winter nights, small non-migratory birds enter a place of shelter. This can be a natural cavity or man-made structure that provides protection from the wind and predators.

When the sun goes down, the birds slowly enter a state of torpor. They interrupt their shivering for short periods of time, which allows their bodies to slightly cool. On average, birds can lower their body temperature by about 10 degrees. At the same time, their heart rate and breathing slows. All of this affects their level of consciousness. Although the birds are still partially awake, their reflexes are extremely slow, making the birds vulnerable and seemingly unconscious. Toward morning, the shivering resumes full-time, the body core temperature rises, and the birds wake up and become active again.

Torpor lasts all night, saving energy for when the birds need it most. For example, all day long, small birds, such the Black-capped Chickadee, feed to put on enough fat to fuel shivering and stay warm. During the day they are able to add a small amount of extra fat. This fat reserve serves as their fuel throughout the night. If the birds don't have enough fat, they will run out of fuel and not make it to dawn. Going into torpor helps the birds conserve their precious fat. On average, a Black-capped Chickadee has a 10–20 percent increase in fuel efficiency when in torpor.

Black-capped Chickadee

American Goldfinch

NOMADIC SPONTANEITY

Very little is known about nomadic birds. While we don't have many species of true nomads that wander around the country with no pattern to their seasonal movements, there is one species that might fit this category.

The American Goldfinch, also called the Wild Canary, is a bright yellow backyard bird. Banding records show that this species endures some winters in northern states, while in other winters it enjoys the warmth of southern states. It appears to be staying wherever food is abundant and moving on without any regard to the season.

Bohemian Waxwing

Yellow-rumped Warbler

FUELING FOR THE TRIP

Birds need extra fuel reserves during migration. Prior to a trip, migrators feed feverishly in a process called hyperphagia. Typically, they increase their food consumption by about 25–30 percent and often will eat more fruit, which is quickly digested and converted into fat. Many warblers, thrushes and sparrows switch from an insect diet to a fruit diet just before migration. Studies show that birds are able to select food items with the highest amount of fat from a variety of foods that have the same amount of calories.

Not all fats are the same, and fueling up requires a delicate balance. The trick to fueling a migratory flight is to acquire the right amount of fat and the right kind of fat. Birds need to add fat, but they can't gain too much weight. More weight requires more energy to take off and stay aloft. In addition, the wrong kind of fat results in muscle starvation during long-distance flights.

Birds have two types of fat, white fat and brown fat. White fat helps to store fuel that can be used over long periods of time. Brown fat, also called migratory fat, provides instant access to energy during long migratory flights. The ability to use a special fat to fuel high-intensity exercise is unique to the avian world. Brown migratory fat is deposited all over a migrator's body, just under the skin.

Brown fat produces 8–10 times more energy than other types of fats or fuels. Studies of migratory birds show that this fat is burned nearly exclusively during strenuous flight. The white fat from digestive organs and proteins from muscles that are used for daily fuel are not usually supplied during migratory activity.

Blackburnian Warbler

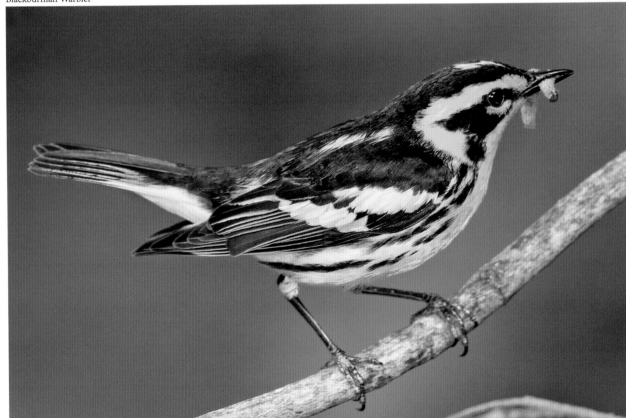

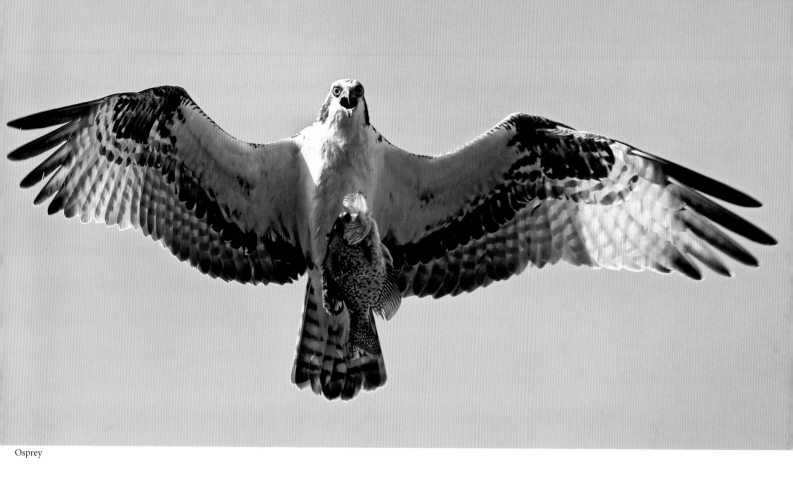

Osprey

The amount of fat accumulated for migration varies greatly among migratory species. Typically, long-distance migrants that cross over large bodies of water or areas with no food will deposit more fat. Typical non-migrators have about 3–10 percent fat in their total body mass, while long-distance migrants have upwards of 50 percent fat. Short-distance migrants deposit half the fat of birds that travel long distances, about 25 percent.

Of course, flying with all of this fat is burdensome and can reduce a bird's maximum distance during a nonstop flight. Still, some birds, such as shorebirds, can fly upwards of 6,000 miles without stopping to refuel. Smaller songbirds can cover up to 600 miles nonstop before needing to feed. Even a tiny hummingbird carries enough fat to make it over the Gulf of Mexico, a distance extending 500–600 miles.

The need to fuel up at nectar feeders is critical for migrating hummingbirds. In a three-week study in California, Rufous Hummingbirds weighed about 3.4 grams when they first arrived at feeding stations at the study site, and about 4.7 grams just before they left for migration. Most fed at the feeders for an average of 10 days, but some remained up to 20 days. Their weight increased by as much as a quarter gram of fat per day, with most of the gains occurring in the first few days. Each bird showed a weight gain of around 40 percent, or about 8 percent per day prior to its departure.

Rufous Hummingbird

EXTERNAL AND INTERNAL CUES

The factors that prompt birds to migrate are not completely understood. However, they can be divided into two general categories: external and internal.

External factors include changes in the amount of daylight, the availability of food and changes in the weather. Taken separately or together, these external events help to cue migrators when it's time to feed for the trip, and later, to fly.

Internal factors have a genetic aspect. It's easier to appreciate this when you look at a species that has individuals living in different regions, but which are responding differently to external cues. The Peregrine Falcon is a good example. Most peregrines that nest in southern regions don't migrate. Other peregrines that nest in regions farther north, including the alpine tundra, are migrators that leave to spend the winter farther south. The migrators are responding to external factors in conjunction with their genetic programming. Their genetics differentiates them from the non-migrating peregrines that live in southern states.

Peregrine Falcon

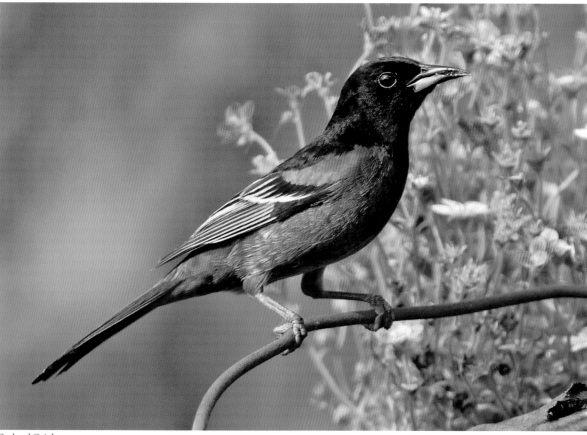

Orchard Oriole

Many other species have another genetic type of internal, or endogenous, cue for migrating. Orchard Orioles and Blue-winged Warblers, for example, are complete migrators that leave long before the weather changes or before food becomes scarce. In late summer, when food is still plentiful, these birds leave their nesting grounds to head south for the winter.

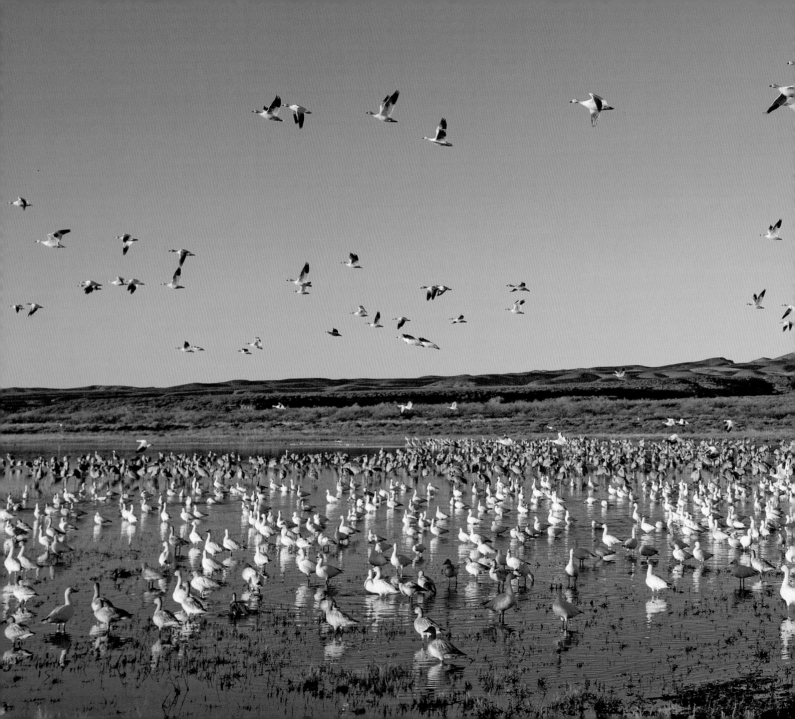

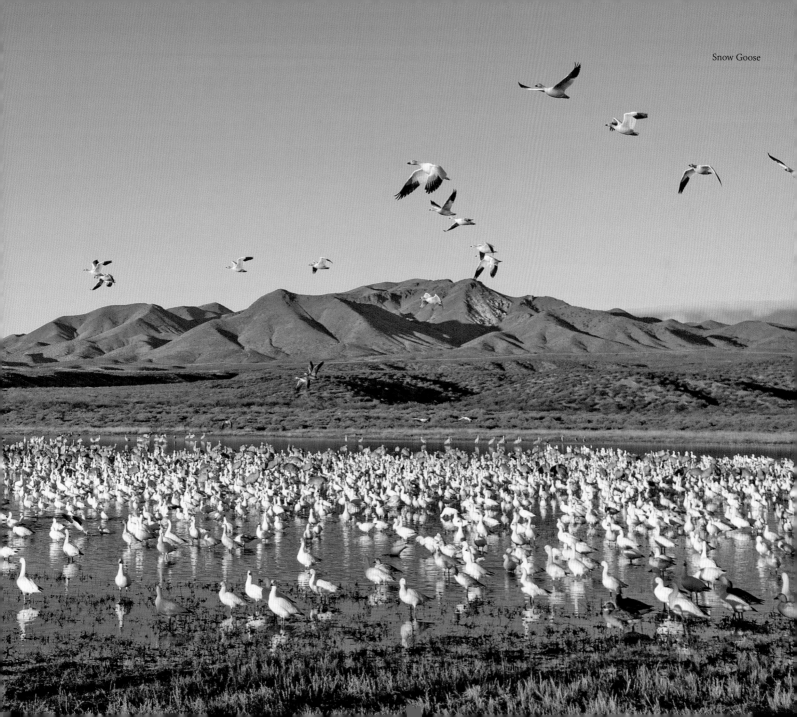

Snow Goose

House Wren

MIGRATORY RESTLESSNESS

During the seasons when birds aren't migrating, most small migratory birds sleep or rest at night. As spring or fall migration approaches, these birds tend to become restless and get more active just after sunset. This behavior is known as migratory restlessness, or *zugunruhe*. From *zug*, meaning "migration" and *unruhe*, meaning "restlessness," *zugunruhe* was first coined by a German scientist who helped discover the phenomenon.

The amount of daylight from sunrise to sunset is called the photoperiod. As the seasons change, the photoperiod decreases in the fall and increases in spring. Before migration, as the days slowly get shorter or longer, birds perceive the changing amount of daylight. Their endocrine system responds by triggering hormone production. The hormones produced at this time are the controls of most migratory behaviors. One of these hormones, pro-lactin, causes hyperphagia and compels the birds to eat more. It also increases nighttime activity in birds and is thought to stimulate the navigation system in most species.

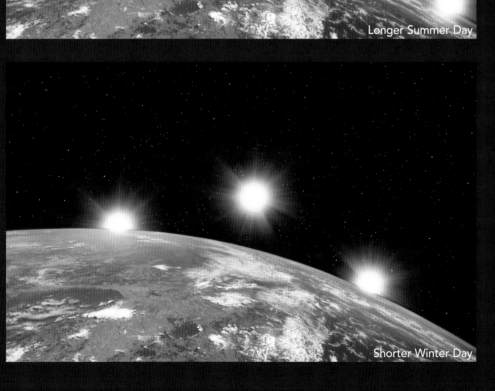

PHOTOPERIOD

Longer Summer Day

Shorter Winter Day

To prove the connection between the photoperiod and migratory restlessness, scientists placed captive birds in controlled environments with artificial lights and slowly changed the photoperiod. When the amount of light changed, the migratory hormones surged in the birds, causing increased feeding and restless activity at times outside of the normal migration schedule.

HORMONAL RESPONSE

While birds migrate in response to a wide variety of external and internal cues, studies have shown that in most species, it is hormone production that actually drives migration. Typically, as long as the migratory hormones are surging in birds, the urge to keeping flying south or north continues. Cues near the wintering or breeding grounds may help hormone production to drop, which, in turn, signals the birds to stop migrating.

Sandhill Crane

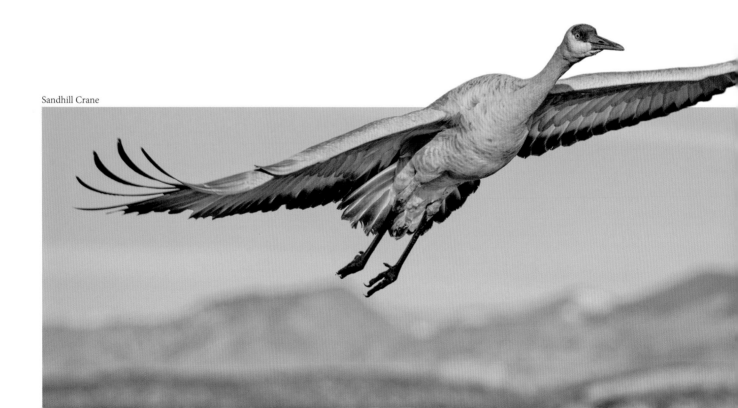

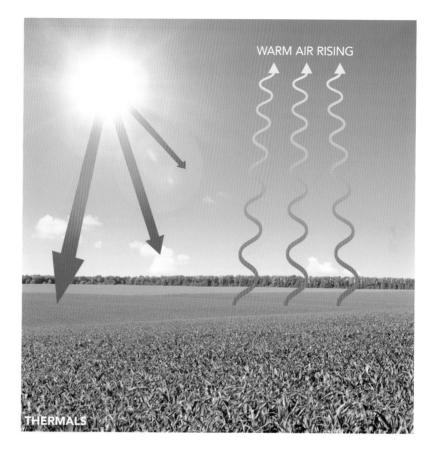

WARM AIR RISING

THERMALS

FLIGHT BY DAY OR BY NIGHT

Many birds migrate during the day. Some of these daytime migrators rely on rising columns of warm air, called thermals, to help carry them upward. As the sun rises higher during the day, it warms the land and creates thermals. Cranes, storks, hawks and other large birds seek thermals and ride them like elevators to the top. As the air rises higher, it cools and slows down. When birds ascend to the top of a column, they glide off effortlessly in the direction of travel and find another thermal to ride.

Swallows, swifts and other birds that eat flying insects migrate during the day, feeding while they fly. Many other birds, such as woodpeckers, jays, bluebirds, robins and blackbirds, make short flights during their trips and stop to feed. Typically, it takes these birds much longer to arrive at their destinations.

Daytime migrants usually start the day promptly at dawn and spend their first couple of hours feeding. Migration gets underway shortly afterward, with most birds taking off at around 10 a.m. Many of these birds will feed again at the end of the day before resting for the night.

However, the majority of small birds, known as the passerines, migrate almost exclusively at night. Most of these birds start migrating during twilight, about 30 minutes after sunset. Passerines usually migrate by themselves, not in large flocks. Other birds may be migrating at the same time and going in the same direction, but these birds aren't in an organized flight or making a coordinated effort.

Modern radar and radio tracking devices have shown that the numbers of birds migrating at night start to build slowly. It's not until around midnight that the numbers begin to peak. The amount of migrants in the air tapers when sunrise nears, with most of the birds landing before daylight.

Red-bellied Woodpecker

Red-winged Blackbird and Brown-headed Cowbird

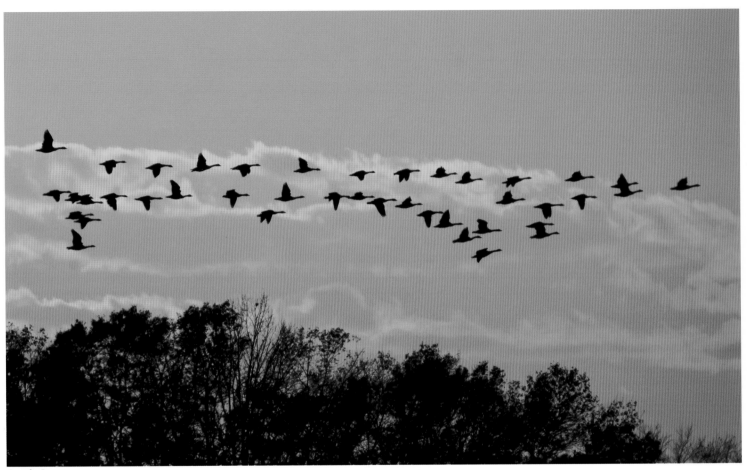

Canada Goose

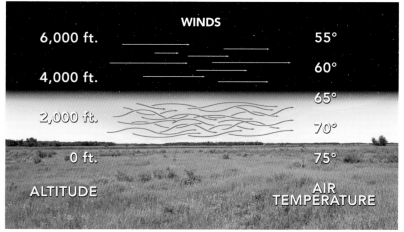

WINDS

6,000 ft.	55°
4,000 ft.	60°
2,000 ft.	65°
	70°
0 ft.	75°

ALTITUDE AIR TEMPERATURE

PERKS OF FLYING AT NIGHT

There are a number of good, sound reasons why birds would migrate at night. The obvious reason is that they evolved into this behavior. Because so many bird species today migrate at night, scientists propose that in the past, the most successful birds also migrated at night. They suggest that over time, the descendants of the surviving nighttime migrators became the dominant species.

Flying at night allows birds to feed and rest during the day. Each morning the birds will land in a new place that they do not know, making the task of finding food just that much harder. They use the daytime hours to find enough food to fuel the coming night's activities.

The atmosphere at night is much more favorable for flight than it is during the day. At night, the air has less turbulence, which makes it attractive to slow-flying small birds. Typically, nighttime airflows are more flat (laminar), providing better support for birds in flight. Air temperatures are cooler as well, reducing the stress of overheating and dehydration associated with long, strenuous daytime flights. Moreover, birds don't need to stop as often to cool off, making it possible for them to fly farther each night and finish their trips earlier.

In addition, there are fewer predators hunting for birds that migrate at night. And equally important, navigation with the stars is perhaps easier than using geography to plot the course of the route during the day.

European Starling

MAKING SENSE OF NAVIGATION

How birds navigate is still a great mystery. Many theories have persisted over the years, but now new studies and ideas help to explain the complexity of navigation.

If you've ever been lost in the woods and you unwittingly walked in circles as you tried to get out, you know how important a compass would have been to keep you heading in a straight line. So how is it possible that birds, especially young birds, can navigate in a specific direction without getting lost? For example, the young of most of our small songbirds and some larger species, such as the Common Loon, migrate on their own, without the company of adults to show them the way. Birds such as these, which hatched during spring (hatch-year birds), are migrating for their first time in the fall. How can hatch-year birds know where to go and how to get there?

Research that gave us a peek into the mystery of migration started in the 1950–60s. One of the first studies involved trapping and banding more than 11,000 juvenile and adult European Starlings in Europe. After affixing a leg band to each individual, the birds were transported nearly 400 miles to the southeast of their wintering grounds and released for fall migration. Researchers reported that the juvenile, first-time migrants migrated in the same direction and flew the same distance that they would have if they had flown from their home range to the wintering grounds.

The adult starlings, however, migrated successfully to the wintering grounds, even though they had to fly in the opposite direction than they normally would have to get there. This study showed that young starlings appear to have an innate navigation coding that automatically guides them in the right direction to get to the right place. After their first experience of migration, they can pinpoint their destination and return there from just about any direction.

In a more recent study, several hundred White-crowned Sparrows were trapped and banded in southern California. Some were flown 1,800 miles to Baton Rouge, Louisiana, while others were flown 2,400 miles to Laurel, Maryland, and then all were released. The next year, more than 30 of these banded birds were trapped again in the same area in California. Where the birds stayed during the year between their banding and recapture is unknown, but the fact that they found their way back from different parts of the country and from very far distances proved that their navigation system is outstanding.

White-crowned Sparrow

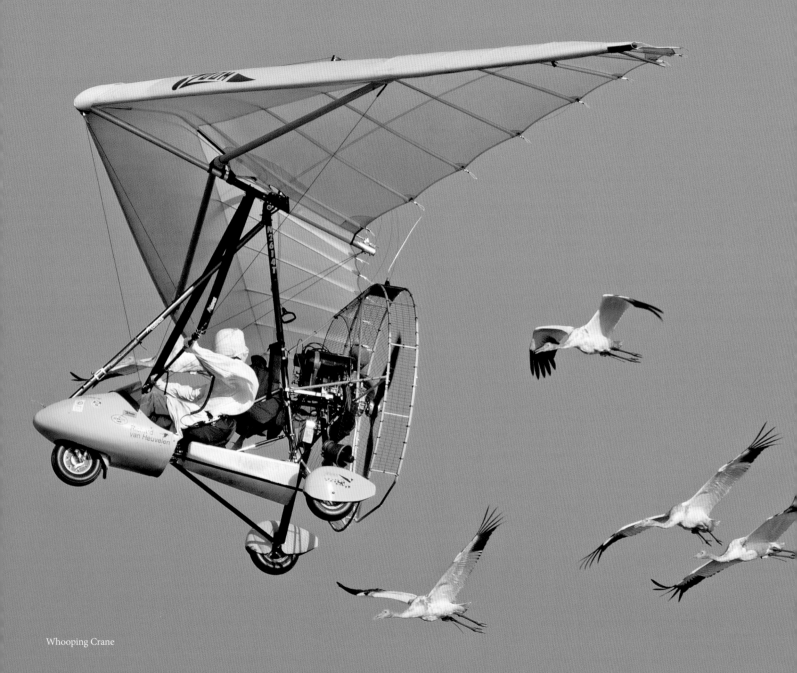

Whooping Crane

LEARNED MIGRATION

Many more studies show that once birds migrate automatically via their genetic coding or by learning the route from their parents, they are able to navigate to and from the wintering grounds with exact precision year after year.

Folks working with the Whooping Crane, an endangered species, demonstrated the process of learned migration after Whoopers were reintroduced to central Wisconsin. From 2001 to 2015, to teach the captive young cranes a migration route, handlers wearing crane costumes would train a small group to follow an ultralight aircraft. Each year in the fall, a new group of young would follow the aircraft all the way to Florida, where they would spend the winter along the Gulf Coast.

Many stops would be made during the annual journey south, and the trip would take several months to complete. In the spring, the cranes didn't need to be shown where to go—they returned to Wisconsin all on their own. What is also remarkable is that they made it back in only 4–6 days! Now, as adults in the wild, these cranes are migrating on their own and teaching their young the migratory route as well.

About 250 Whooping Cranes make up the only wild population west of the Mississippi River. The young in the West have no need for intervention with aircraft. They learn the way to their wintering grounds in Texas by just following their parents.

Like the Whooping Crane, if some species of birds aren't shown how or where to migrate, they will not migrate. The Peregrine Falcon is another good case in point. This species was nearly killed off in the United States for a variety of reasons that were mostly due to poor human choices. Later, a limited number of breeding peregrines from various regions were reintroduced into cities across the country.

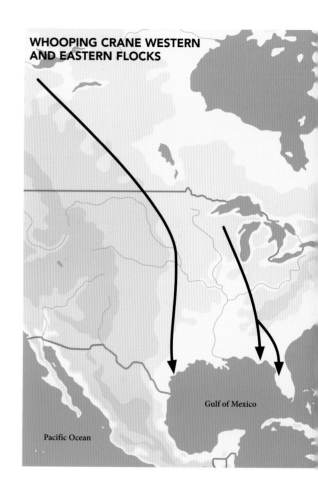

WHOOPING CRANE WESTERN AND EASTERN FLOCKS

Gulf of Mexico

Pacific Ocean

As it turns out, some of the breeding peregrines from the northernmost regions were highly migratory, and some from the regions farther south were not. When these raptors bred together, they produced a mixed brood of migrators and non-migrators. The non-migrators that ended up living in the northernmost regions adapted and are doing well without migrating.

Another difficult situation involving the need to learn migration is occurring in Minnesota. When the Trumpeter Swan became locally extinct (extirpated) across the state, new individuals were introduced with great success. In the past, Trumpeters migrated to Kansas or Arkansas to find open water and escape the northland ice. However, most of the introduced birds had no predecessors to show them how or where to migrate. Today, thousands don't know how to migrate and are forced to remain, gathering along a few open parts of the frozen Mississippi River each winter. They seem to be adapting and doing well, as Minnesota now has the largest population of Trumpeter Swans in the Lower 48.

Trumpeter Swan

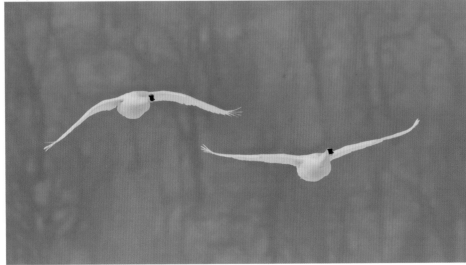

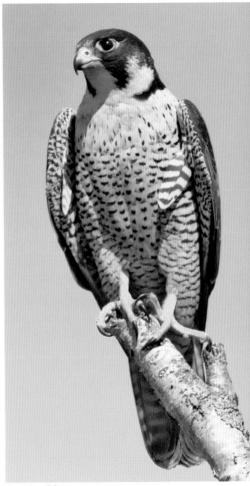

Peregrine Falcon

NAVIGATION MAPS

Nearly all scientists agree that birds have some kind of internal navigation map, but they suggest different theories about it. Some think it's a highly sensitive olfactory map that relies on a bird's ability to smell odors that people can't detect, which emanate from specific geographic regions. In migration studies using pigeons, when their ability to smell was hindered, the pigeons couldn't find their way back home. Despite hundreds of olfactory studies and papers published later, there is still no conclusive evidence that an olfactory map exists.

More avian biologists have long held to another theory, called a magnetic map, or magnetic compass. Proof of magnetic sensitivity and directional orientation came when researchers positioned the coils of a Helmholtz magnetic field device at right angles and placed them around a caged songbird. By changing the amount of electricity running through the coils, the researchers were able to create magnetic fields and manipulate the direction of north and south within the birdcage.

HELMHOLTZ MAGNETIC DEVICE

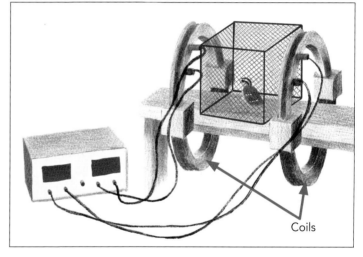

Coils

To ensure that there was only one variable to test for direction, the bird was prevented from seeing the sun and stars for many weeks prior to the experiment. The researchers used the apparatus to alternate the direction of the magnetic fields within the cage, and the bird's orientation responded in kind each time, proving that birds not only feel magnetic fields, but they also use them to help with their navigation.

MAGNETIC COMPASS SENSITIVITY

While birds are now known to be sensitive to the pull of the earth's magnetic poles, a magnetic compass is easier to accept than it is to understand. The magnetic field gets stronger as birds move toward the South Pole or the North Pole, theoretically making navigation easier the farther the birds fly away from the equator.

However, scientists agree that for a successful navigation system, birds would need to be able to sense incredibly tiny differences in the magnetic field at any given point on a map. This level of sensitivity is much higher than the sensitivity of a compass needle to the magnetic field.

Additional studies, once again with pigeons, only served to raise more questions about magnetic compass sensitivity in birds. When homing pigeons were released near strong magnetic anomalies, such as large deposits of iron near the surface of the earth, they flew randomly, without regard to their magnetic map until they escaped from the magnetic interference. Afterward, they turned and headed right back home.

Was their highly sensitive navigation system overloaded and short-circuited? Do places with magnetic irregularities cause the magnetic compass to sometimes point to true north instead of magnetic north? Until the scrambled behavior of these pigeons is explained, more investigation into magnetic sensitivity is needed.

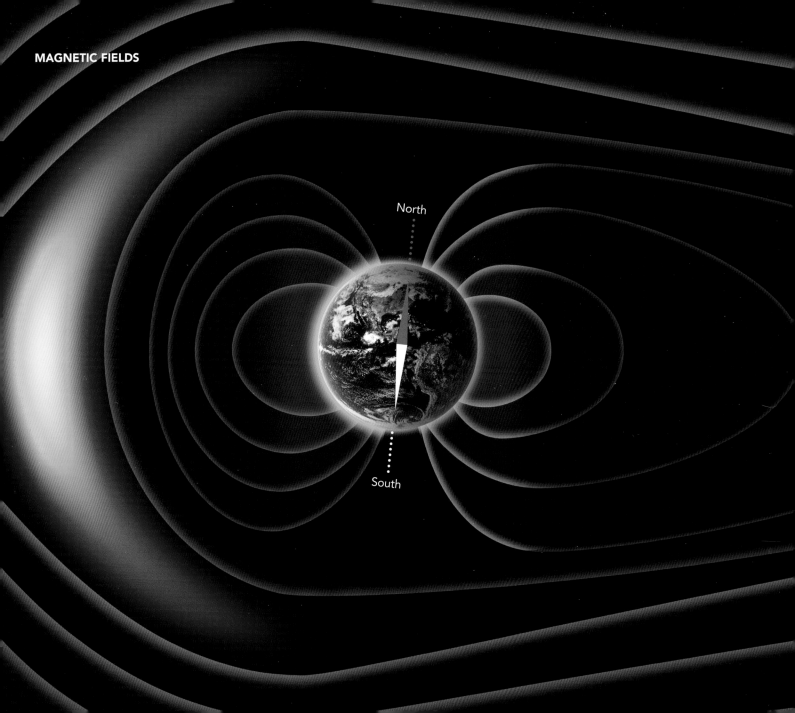

MAGNETIC FIELDS

North

South

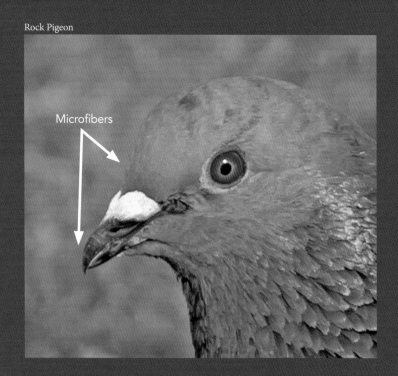
Rock Pigeon

Microfibers

MORE THAN ONE SENSE, ONE SKILL

When it comes to magnetic sensitivity in birds, there is more to examine besides the internal compass. For example, a pigeon has microfibers located in the tip of its bill and in the frontal lobe of its brain. Scientists believe that these features may help pigeons feel the magnetic pull of the poles. However, this might just be the tip of the magnetic iceberg, so to speak, in migrating birds.

No doubt, birds don't rely on just one sense to navigate to and from the wintering and breeding grounds. To accurately bring a bird back to a very specific spot, it very likely takes a combination of senses and skills. The Osprey, for instance, appears to use a magnetic compass for long-distance routes, as well as visual clues, such as major landforms, that indicate when it is close to its destination.

It really is amazing how birds navigate so naturally and seemingly without effort. But even after all of the remarkable discoveries over the past 50 years, we still have much more to learn about how the abilities of birds work together to get them where they need to be.

Osprey

CIRCADIAN CLOCK SCHEDULE

While an internal compass is amazing, it won't get a bird to its destination at the right time. Imagine being in a new place and having a compass. You could use it to travel in a straight line, but it couldn't tell you when to leave. All birds need an internal clock, or a circadian clock, to let them know the time of day and the season, regardless of whether or not they migrate. Migrators need to know the time of year and the time of day or night to help them know when to migrate.

Scientists have proved many times that homing pigeons have an internal clock. After keeping pigeons indoors for several days, scientists used artificial light to change the light cycle, which would alter the birds' internal (circadian) clock. When the birds were released during the day, they interpreted the sun based on their altered clock and flew in a wrong direction, as predicted, to fly toward home.

People can tell by the sun's position whether it's morning, noon or late afternoon. Birds apparently ignore the exact position of the sun and rely on their internal clock instead to keep them on schedule. I suppose this makes sense since the sun doesn't shine every day and the birds still need to migrate regardless of cloud conditions.

Rock Pigeon

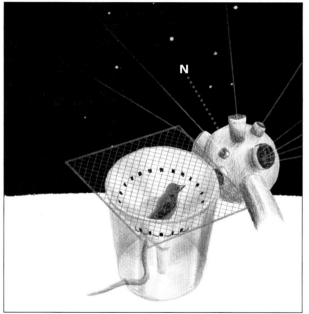

USING THE STARS EN ROUTE

Many studies have shown that nighttime migrators use the stars to help them navigate in the correct direction. In the 1960s, an orientation cage was developed. It was a cone-shaped cage with paper walls, an inkpad at the narrower bottom, and a mesh wire over the wider top, which kept the birds contained while providing a clear view of the stars.

When the birds stood at the bottom, they would get ink on their feet. At night, the birds would line up and try to move or fly in one direction according to the stars overhead. Their inked footprints on the walls of the cone clearly showed their preferred direction of travel.

Later, in another study, Indigo Buntings were kept in a similar orientation cage and placed in a planetarium with a starry night sky projected on the ceiling. Each night the sky was turned in a different direction, and predictably, the birds compensated for the shift in the stars.

Bald Eagle

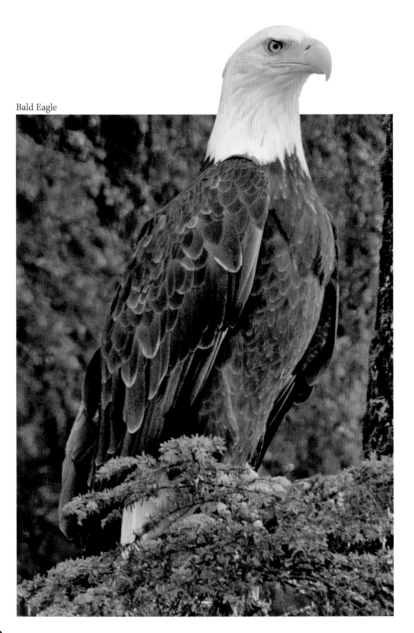

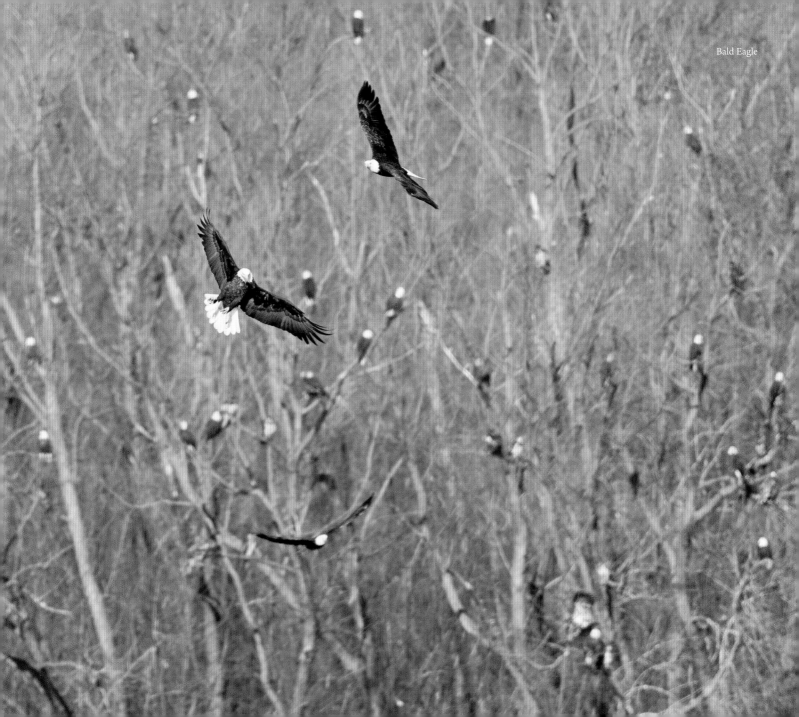

Bald Eagle

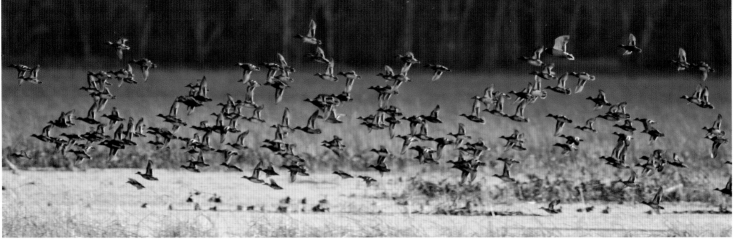
Green-winged Teal and Mallard

MIGRATORY FLYWAYS

Many birds use landforms to help guide them along during migration. Mountain ranges, large canyons, lakes, rivers, oceans and other geologic features are easy to spot from the air. They help birds to know where they are, especially when they've seen the topography before.

Many of our waterfowl, such as Green-winged Teals and Mallards, migrate up and down one of the four major flyways. The Pacific Flyway runs along the West Coast from Alaska and Canada into western South America. The Central Flyway extends from the Rocky Mountains to the Missouri River, reaching up through Canada's boreal forests and down through Mexico into the tropics of Central America. The Mississippi Flyway covers central portions of the United States and Canada, crossing the Gulf of Mexico and extending into South America. The Atlantic Flyway extends from the eastern United States and Canada down through the Caribbean into many parts of South America.

Each spring and fall, many millions of other birds, such as Bald Eagles, use these flyway corridors to migrate. In fact, the flyways are some of the best places to see and appreciate migrating birds.

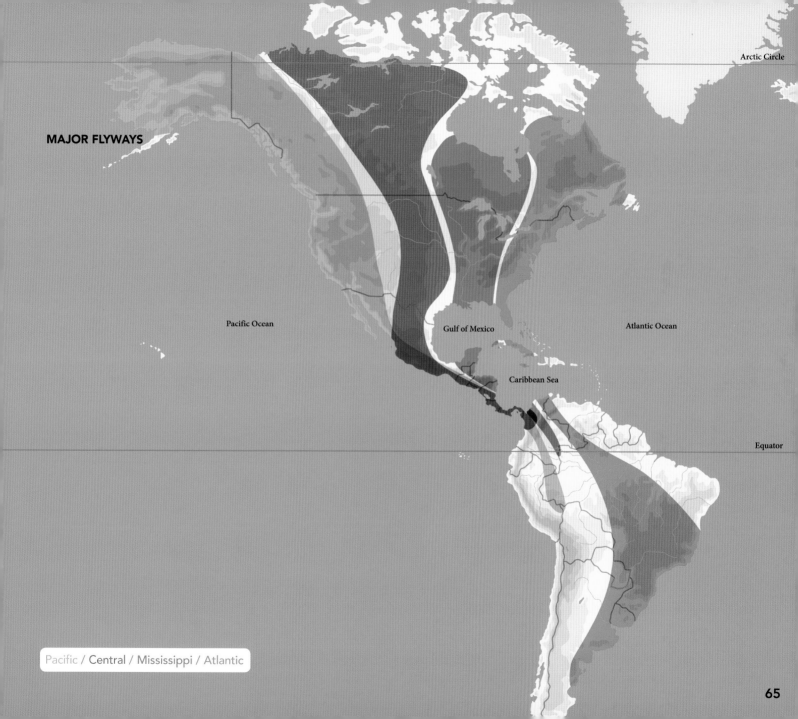

MAJOR FLYWAYS

Arctic Circle

Pacific Ocean

Gulf of Mexico

Atlantic Ocean

Caribbean Sea

Equator

Pacific / Central / Mississippi / Atlantic

65

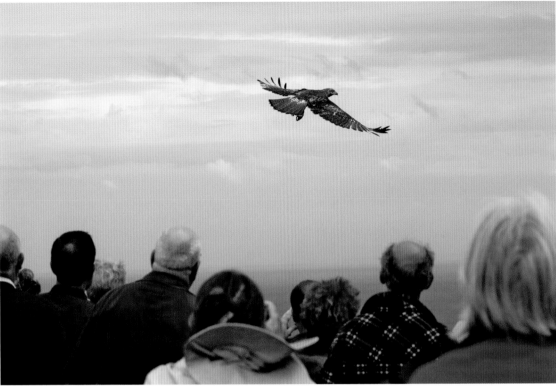

Red-tailed Hawk at Hawk Ridge Bird Observatory

Hawk Ridge Bird Observatory in Duluth, Minnesota, for example, is a great site to see migrating hawks in the Mississippi Flyway. Groups of hawks (kettles) ride on warm-air thermals, which help them gain altitude. Large, cold lakes, such as the Great Lakes, don't generate warm columns of air, so hawks avoid flying over these landmarks. In the fall, tens of thousands of hawks migrate out of Canada and northern Minnesota. When they reach Lake Superior, instead of flying over it, they follow the shoreline down for more than 200 miles to its southern tip at Duluth. This coastal route concentrates the migrators at Hawk Ridge. On good days, more than 10,000 raptors fly over or past the ridge.

WINDS AND DRIFT

Wind plays a part in navigating during migration. Headwinds aren't too much of a challenge for migrators, although most birds won't fly against a significant headwind. Strong tailwinds will push migrators along from behind and increase their flight speed. Studies of radar images at night show that when there are tailwinds, more birds migrate.

A strong wind coming at birds from either side will significantly hinder their ability to stay on course. Side winds cause lateral movement, called drift, as the birds move forward. To compensate for drift, birds need to calculate how much of the flight path is being affected, and then adjust their flight by turning slightly into the direction of the wind. Obviously, this makes an internal compass essential to automatically correct for drift. Visual clues also help, giving daytime migrators caught in a side wind the advantage over night-flying songbirds that have drifted sideways.

In one study in New York, migrant birds near the Hudson River were captured and moved away from the river. These birds corrected their flight to get back to the river. Other migrants captured near the Hudson were released within eyesight of the river, but these birds continued to follow the river south without correcting their position. The findings indicate that birds use major landmarks to help offset drift due to major crosswinds.

WIND DRIFT

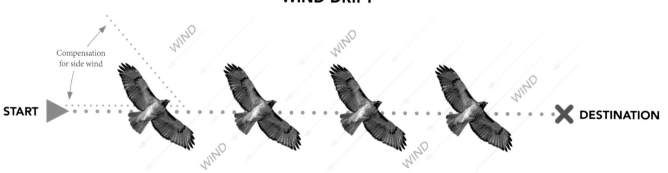

Compensation for side wind

START

WIND

DESTINATION

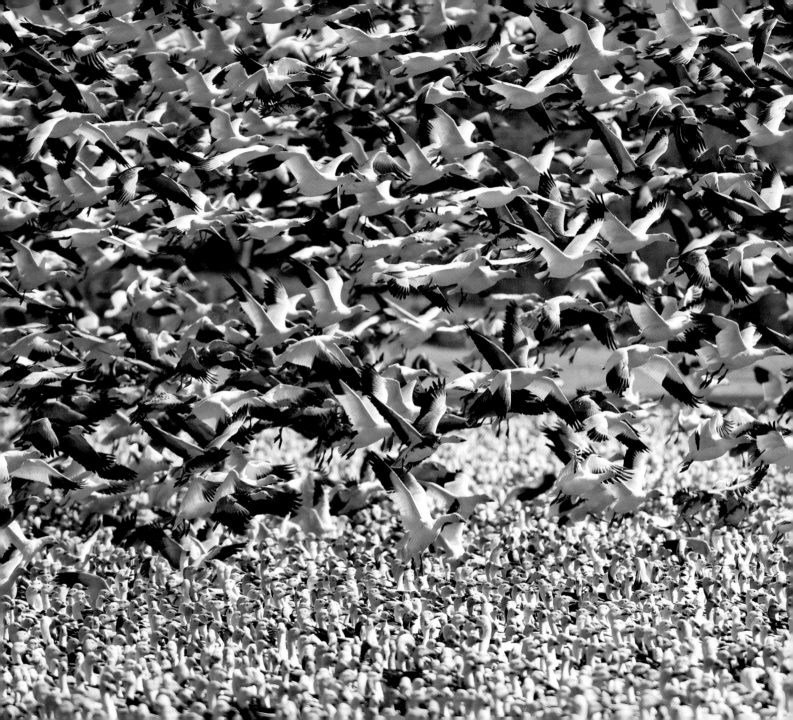

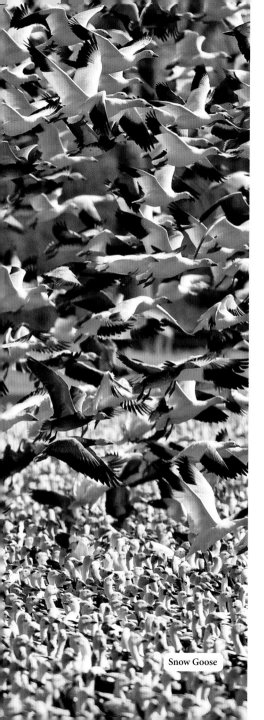

Snow Goose

FLOCKS VS. SOLO FLIGHT

There's safety in numbers. A bird is safer migrating in a flock than it would be flying solo, and it's even more safe in a large flock. The chances of being eaten by predators decrease the most when birds travel in large flocks. The more eyes watching for predators, the safer the birds will be.

Many species of birds migrate in large flocks. Snow Geese and Sandhill Cranes are classic examples. Huge mixed flocks of upwards of tens of thousands of these birds gather and fly together during migration.

While leading a birding trip in south central Nebraska for the annual spring migration of Sandhill Cranes, I drove my bus with 12 birders under a flock of migrating Snow Geese. Glancing down at the odometer, I noted the miles. I drove for more than 5 miles at 50 mph before emerging out from under the cloud of migrating birds. We estimated an easy half a million geese in just that one flock!

Other smaller species, such as the Brown-headed Cowbird, Red-winged Blackbird and Common Grackle, also migrate in large mixed flocks. These birds fly in tight formation and often low to the ground. You may have seen them moving along from one spot to another in a twisting, turning pattern, like a cloud of smoke (murmuration). Often they land on the ground, where they feed for a short time before they burst into flight again.

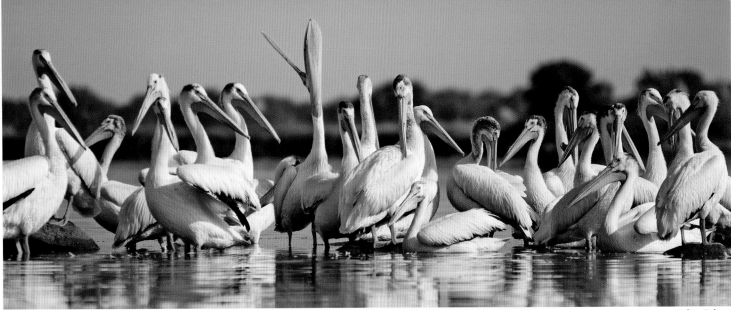

American White Pelican

American White Pelicans migrate in medium to large groups during the day. They are often seen high up in the sky, flashing their long white wings while banking in the wind. These birds fly from coastal areas in the South up into the Prairie Pothole regions in Minnesota, North Dakota and Canada to nest each spring.

Waterfowl are classic group migrators. Hundreds, if not thousands, of these birds will migrate at the same time, going to the same place. Their movement can sometimes create clouds of birds, which are stunning to see.

Other birds, such as hummingbirds and warblers, migrate on their own. When they strike out, it is often after dark, and they usually go on a long journey. Most of our very small birds are sole migrants. They may travel at the same time and altitude as similar birds, making them look like they're part of a group, but they have no connection with other migrators.

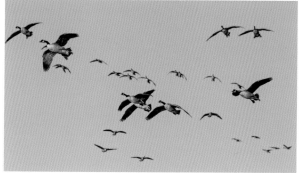
Canada Goose

ELEVATION CHALLENGES

Birds are specialized creatures. We see them flying nearly every day, but rarely do we stop to appreciate why they can fly. Each part of a bird's body is designed for flight. Birds obviously have wings and feathers, but they also have hollow bones and lack teeth, making them lightweight. They have oversized eyes and massive optic nerves that send visual data to the brain, which processes and responds to the visual information at ultra-high speeds. Their brain is the reason why birds can fly through a forest full of trees and not crash into a single branch.

Flight is, of course, the key ingredient for migration. Some birds fly at low elevations, while others soar at much higher heights. Typically, smaller birds fly at lower elevations and larger birds fly higher up, where the air is thin. Some birds need to cross over tall mountain ranges, migrating above 18,000 feet to reach their destinations.

Most small songbirds migrate at night and fly below 2,000 feet. An estimated 90 percent of all nighttime migrators fly below 6,000 feet. High-flying birds include Mallards, which are known to migrate at elevations above 21,000 feet. Eagles and vultures migrate at higher heights than Mallards, and Canada Geese have reportedly flown as high as 29,000 feet.

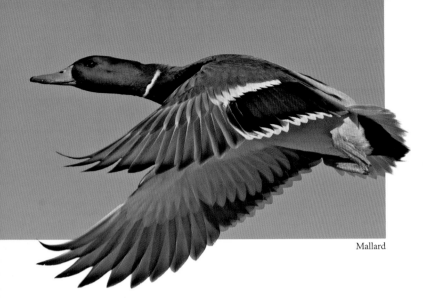
Mallard

High-flying migrators have a number of challenges. For example, the higher the elevation, the thinner the air becomes. Low-density air requires birds to work harder to stay aloft. All species that migrate at high elevations are equipped for this extra burden, with longer wings than their bodies. Some ducks, such as Mallards, have large wings compared with their bodies.

Birds that migrate at extremely high elevations, such as geese, also need to flap harder in the thinner air. There is less oxygen at high elevations, so this increases the demand for it and burns more calories. Moreover, the higher birds fly, the colder and dryer the air gets. Not only does this intensify the need to keep warm, but the loss of water through excessive breathing and evaporation can also become a problem.

To compensate for these difficulties, birds in flight at high elevations need to hyperventilate to obtain enough oxygen. In addition, their hemoglobin, the part of the blood that transports oxygen to the muscles, has a higher oxygen-binding affinity and effectively transports oxygen to their flight muscles. The cold air can also be beneficial because it helps to keep the birds from overheating in flight. In addition, the birds don't fly at high elevations for long periods of time. They move down to lower elevations as needed, which helps to reduce the demand for oxygen and stabilize their body chemistry.

FLIGHT SPEEDS

You might think that the speed of migration is relatively the same in spring and fall, but this is not true. During spring, migration seems more like a race to the breeding grounds. All studies indicate that the first birds to return will claim the highest quality territories with the most food resources. So spring migration is a rather fast event with a lot at stake. Most birds will migrate about 200–500 miles per day, weather permitting.

Compared with migration in spring, fall migration is somewhat slow. As long as food is plentiful, the birds are in no hurry to make their way south. Sometimes they skip migrating for a day or two when the weather is good and winds are favorable, choosing instead to stay and rest and feed. Other times they wait for optimal weather and wind conditions.

In general, the smaller the bird, the slower it flies during migration. Smaller birds, such as House Wrens, migrate at just over 10 mph. Larger sparrows, such as White-throated Sparrows, fly at about 18–22 mph. Slightly larger Baltimore Orioles migrate at speeds of around 22–30 mph. Shorebirds, such as American Golden-Plovers, fly faster, at about 30–40 mph. Much larger Canada Geese have migratory speeds of around 32–42 mph, and Ospreys migrate at approximately 35–46 mph.

House Wren (top), Baltimore Oriole (middle) and American Golden-Plover (bottom)

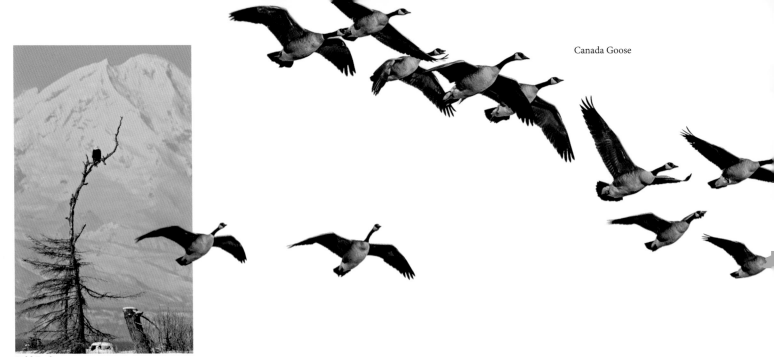

Canada Goose

Bald Eagle

These are only general speeds of these species during migration. Due to changing wind speeds and other factors, the birds will migrate slightly faster or slower at times. High-flying migrators, such as Canada Geese, can attain their fastest flights when soaring down to lower elevations.

In another study, Bald Eagles that wintered in Colorado had transmitters affixed that enabled researchers to monitor spring migration. On average, the eagles flew about 125 miles a day on their way to breeding grounds in Saskatchewan, Canada. Many of the birds would fly when the weather was good, and then would sit and wait during days with unfavorable weather. Interestingly, one eagle left on the first day of migration and ran into a snowstorm. The eagle turned around and went back to the wintering site, where it waited several days before heading back out for the spring migration northbound.

ENERGY IN FORMATIONS

Many species that migrate in flocks will fly in a formation, or pattern. Some birds, such as geese, swans and cranes, fly in a classic V shape. Others, like Double-crested Cormorants, move in straight lines or a single file formation.

Flying in formation helps birds save energy. In a V formation, each bird in the line is farther to the side and slightly higher than the one ahead of it. As the birds flap their wings, they create rising and swirling air currents, called a vortex. The birds following in the V are taking advantage of the vortex and riding on the turbulence, which is giving them a boost, or lift.

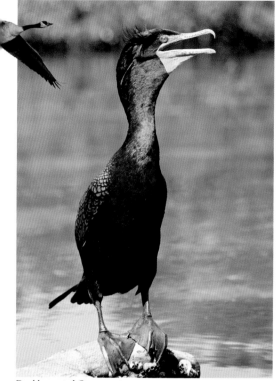

Double-crested Cormorant

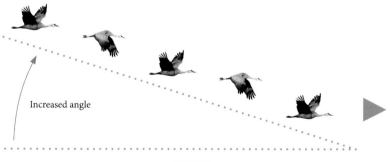

Increased angle

VORTEX

Migrating in a straight line creates a similar advantage for birds, called drafting. Drafting is easy to understand when you think about driving close behind a large truck on a highway. As the truck moves forward, it displaces air. This creates low pressure in an area directly behind the truck, giving you, following behind, a smoother ride. Air moving over the top and bottom of the truck converges in the middle and pulls you along, which feels like cruise control. The air on the sides of the truck is much more turbulent, making it harder for you to pull out to pass. When birds migrate in a line, one behind another, they create a similar drafting effect that helps them to save their energy.

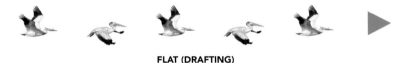

FLAT (DRAFTING)

Until recently, all of this was just a theory. A study using American White Pelicans, which fly in V formation, provided the proof of energy savings. Researchers implanted tiny heart rate monitors in the birds. As the birds flew in formation, their heart rates were recorded. Compared with the lead bird, the birds following in the V had slightly slower heart rates. It was calculated that they saved upwards of 20 percent energy in this formation.

Now the question is, who is the leader of the formation? Is it the strongest bird, or the most dominant? No, the leader is any random individual in the flock. Birds rotate into the lead position randomly, not in an organized pattern and not by strength or ranking within the flock. As the flock shifts and some individuals move around, one bird suddenly finds itself as the lead bird and the others fall into order. Simple as that.

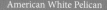
American White Pelican

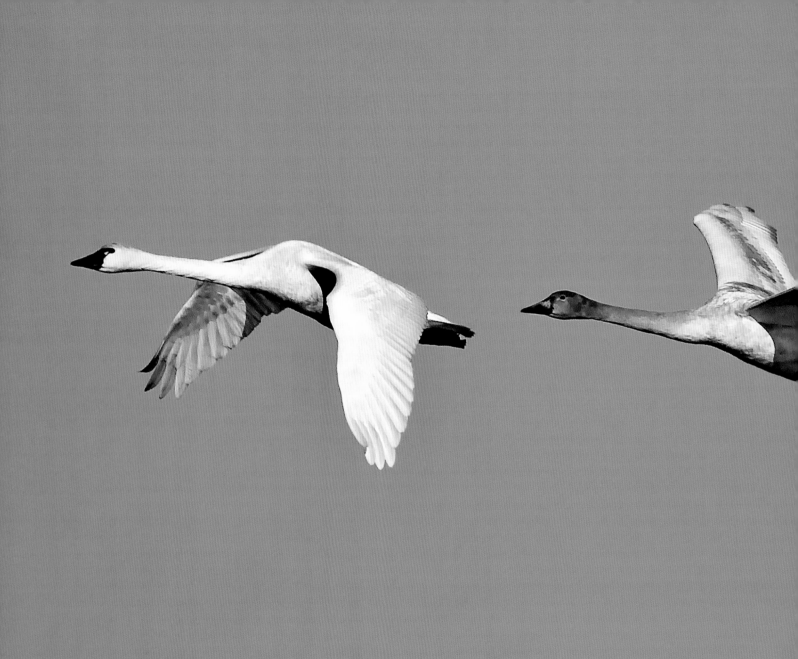

Tundra Swan

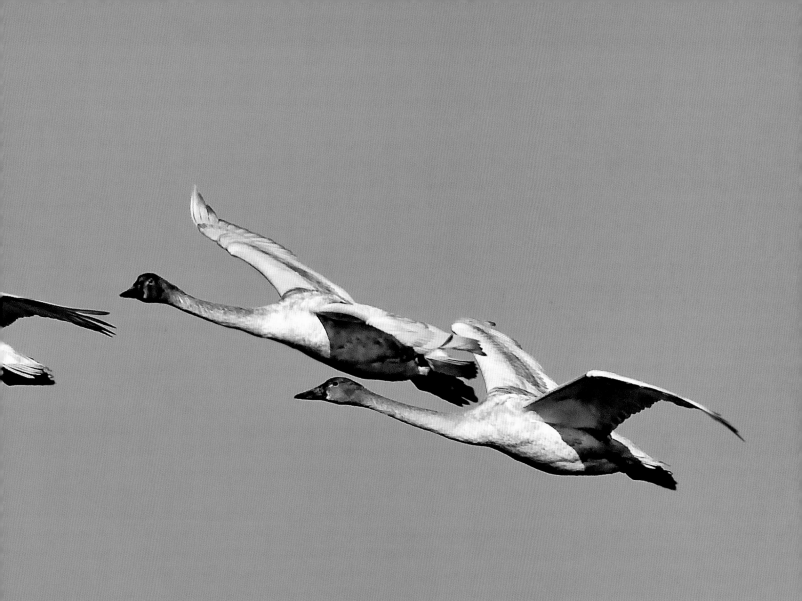

DESTINATIONS, START TO FINISH

Birds migrate to countless destinations all over North America, making short jaunts or long journeys. Some birds fly just a couple hundred miles to avoid the coldest parts of winter, while others migrate thousands of miles to winter in the tropics. In some species, the males and females spend their winters in different places.

Dark-eyed Juncos are sparrow-like birds that breed mostly in the North Woods of Canada and Alaska. Each fall they move out of their home range and start to head south. Multiple studies of banded juncos show that females migrate much farther south than the males. Usually it's mainly the females that fly all the way to southern states. Only the males stop to spend the winter in some northern states, and they have good reasons. Female juncos don't establish territories for nesting; instead, they choose males that have already claimed territories in spring. Male juncos staying farther north during winter are able to get to the breeding grounds first and establish territories before the females arrive.

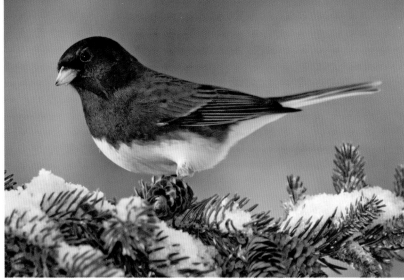

Dark-eyed Junco

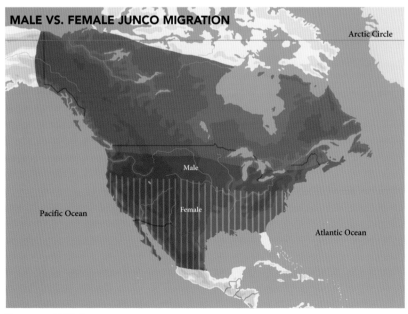

MALE VS. FEMALE JUNCO MIGRATION

Arctic Circle

Pacific Ocean

Male

Female

Atlantic Ocean

Summer / Winter

In a spring migration study of a Swainson's Thrush, researchers outfitted the bird with a tiny radio transmitter. The bird was tracked for 950 miles during its migration north from Arkansas to Illinois. This robin-like bird flew six nights for an average of seven hours per night. It flew as little as 66 miles in one night and 234 miles during another night, flying on average at about 20 mph.

Swainson's Thrush

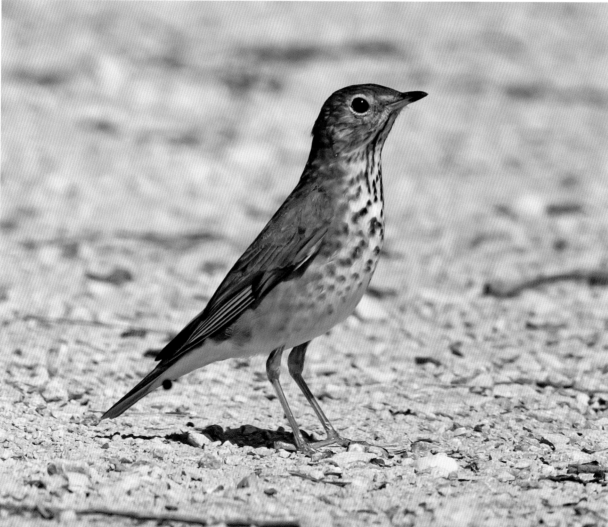

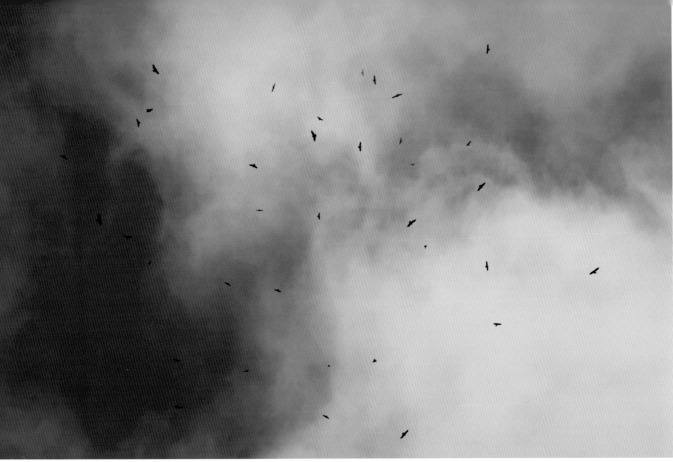
Sharp-shinned Hawk and Broad-winged Hawk

Hawks, such as Sharp-shinned and Broad-winged Hawks, are daytime migrators. Each morning at daybreak, the birds spend an hour or two hunting before they start to migrate. On average, these hawks fly about 20 mph, even though much of their travel is up and down, in and out of warm-air thermal columns. Hundreds, and sometimes thousands, of Sharp-shinned Hawks migrating over Hawk Ridge in Duluth, Minnesota, can be seen circling high up in the sky. On some days these migrators traveled only about 60 miles, while on other days they covered 150–200 miles in 8 hours. Their progress was highly dependent on the weather and wind direction.

For over 30 years I have been visiting Hawk Ridge to see the spectacle of hawk migration time and again. By midday, hundreds to thousands of Sharp-shins can be soaring up high in the blue sky, wheeling and swirling around and around. Groups of birds that fly like this are called kettles because the movement is like a kettle of water boiling up and over.

It was only decades ago that flying more than 600 miles over the Gulf of Mexico from Texas to the Yucatán Peninsula was thought to be impossible for tiny birds, such as hummingbirds. Now we know they make this remarkable nonstop flight twice each year.

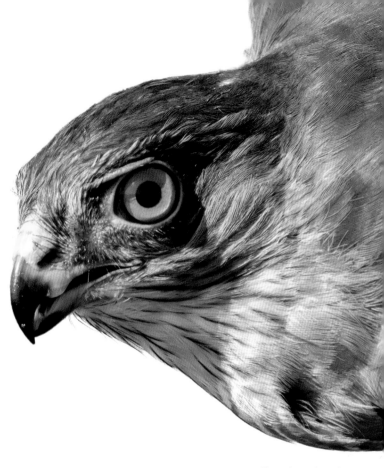

Sharp-shinned Hawk

Ruby-throated Hummingbird

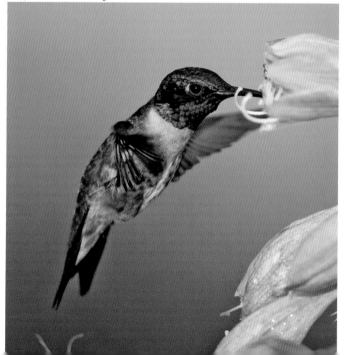

Prothonotary Warbler

The Prothonotary Warbler is a medium- to long-range migrator that summers mainly in the Mississippi River Basin from Minnesota to Louisiana. In the fall it heads south for the winter, following the coastline along the curvature of the Gulf of Mexico down through Mexico, Central America and northern South America. Its migration distance can be 2,000 miles or more.

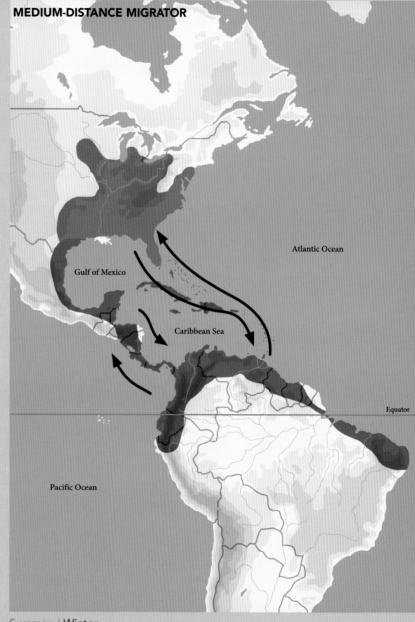

MEDIUM-DISTANCE MIGRATOR

Atlantic Ocean

Gulf of Mexico

Caribbean Sea

Pacific Ocean

Equator

Summer / Winter

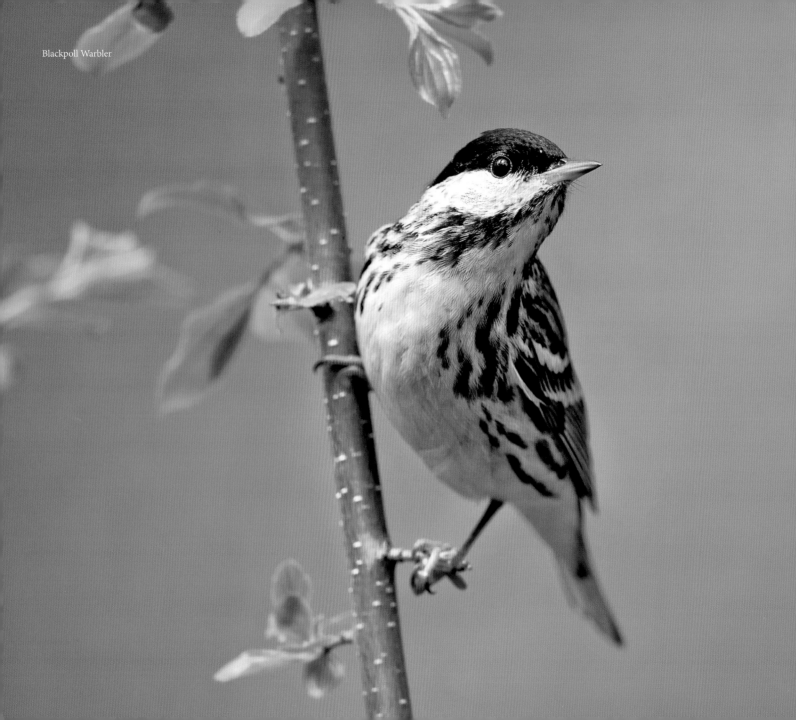
Blackpoll Warbler

One of the more amazing migrations of small birds is the fall migration of the Blackpoll Warbler. This handsome warbler nests in the boreal forests of Canada and Alaska. At the end of the breeding season, it moves east and south to a staging area in New England. There, it gathers in small flocks before migrating over the Atlantic Ocean on a grueling flight to South America. These flocks fly for 4–5 days, traveling about 2,400 miles with no place to stop and rest.

In spring, they return to their breeding grounds, flying right up through the middle and eastern half of the United States into Canada. Many of the birds travel over 5,000 miles to get back to Alaska.

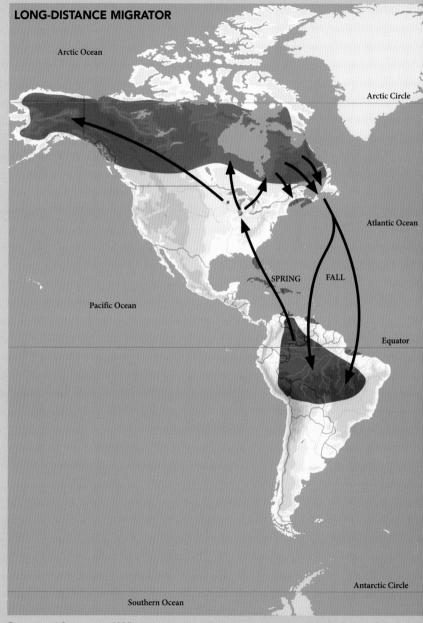

LONG-DISTANCE MIGRATOR

Arctic Ocean

Arctic Circle

Atlantic Ocean

Pacific Ocean

SPRING FALL

Equator

Antarctic Circle

Southern Ocean

Summer / Stopover / Winter

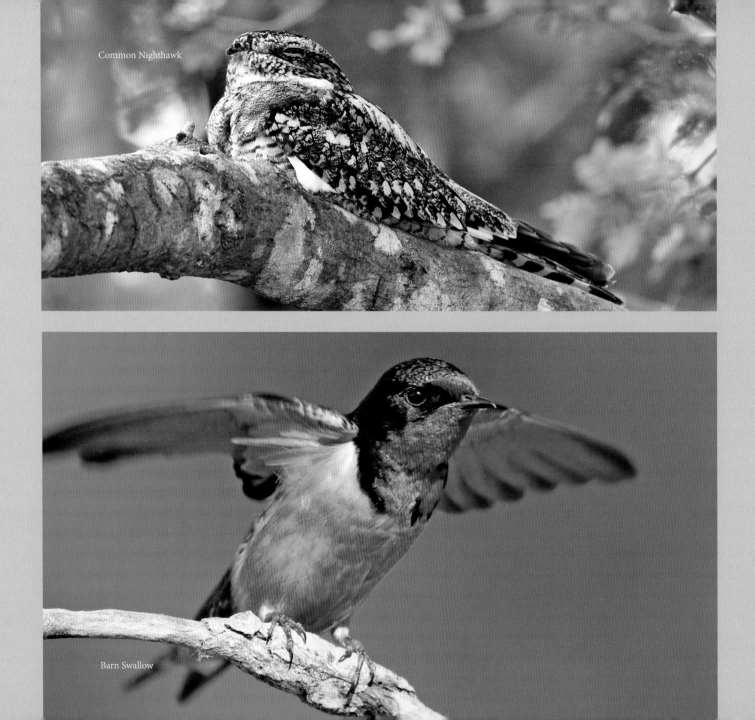

Common Nighthawk

Barn Swallow

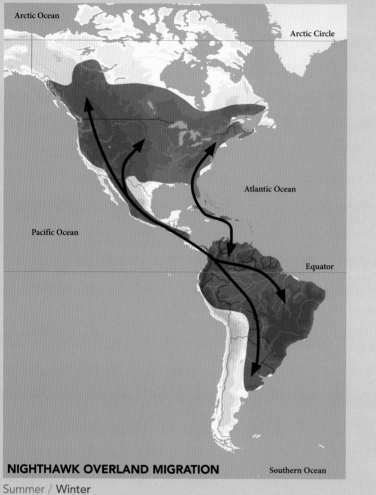

NIGHTHAWK OVERLAND MIGRATION

Summer / Winter

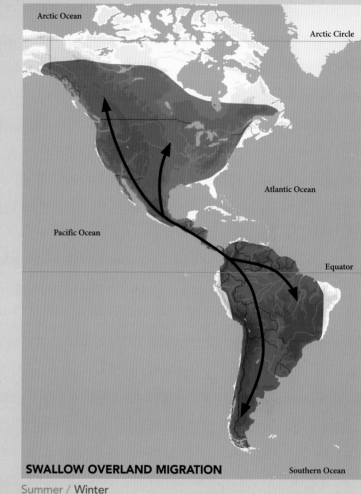

SWALLOW OVERLAND MIGRATION

Summer / Winter

The Common Nighthawk and the Barn Swallow make the longest overland trips in North America. Breeding in the United States and in Canada as far north as the Yukon, these birds fly all the way to South America for the winter, some as far as southern Argentina. Many of the birds travel 4,000–7,000 miles one-way.

Red Knot

Another long-distance migrator is the Red Knot. This medium-sized shorebird has rusty red breeding plumage, and gray and white winter plumage. It breeds in a large swath across the High Arctic, and then migrates all the way down to the southern tip of South America for the winter. At the end of the breeding season, it leaves the High Arctic and heads south, making its first stop at the Delaware Bay along the New Jersey coast, where it feeds and rests.

Many of these birds continue on to the western side of Florida, where they spend the winter around the Gulf of Mexico. Many more leave New England and make a long flight over the Atlantic Ocean until they hit the eastern coast of South America in Brazil. Here, they stop to rest and feed again. These birds continue their migration until they reach the southern tip of South America in Tierra del Fuego, where they spend the winter. During this migration, they travel more than 9,000 miles one-way.

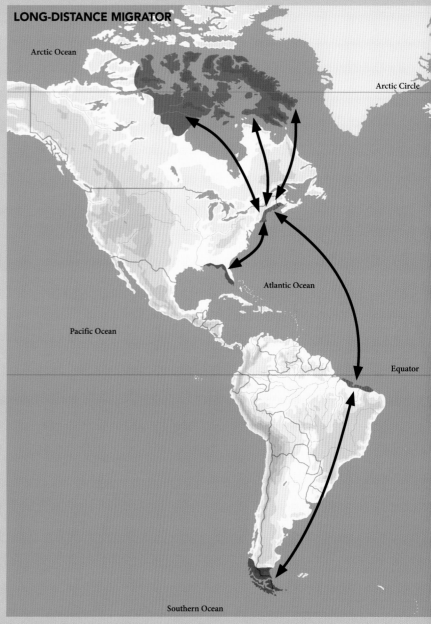

LONG-DISTANCE MIGRATOR

Arctic Ocean

Arctic Circle

Atlantic Ocean

Pacific Ocean

Equator

Southern Ocean

Summer / Stopover / Winter

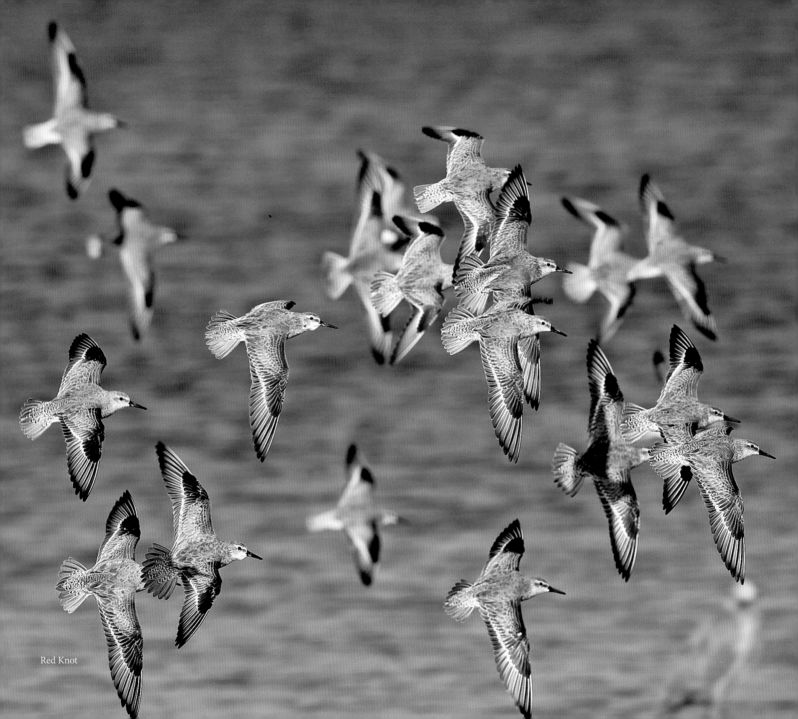

Red Knot

In spring, the Red Knots return along a similar route. Thousands arrive in Delaware Bay during May, starving and weighing half as much as their departure weight. Their arrival coincides with the annual horseshoe crab spawning in the bay. Red Knots are dependent on horseshoe crab eggs on the beach for sustenance during this part of their migration. They feed on the eggs for about a month before continuing their long journey northward.

Like many other shorebirds, Red Knot populations are not doing well. Perhaps due to the decline in horseshoe crabs, Red Knots have declined remarkably over the past 40 years from about 82,000 birds to fewer than 30,000 in recent years.

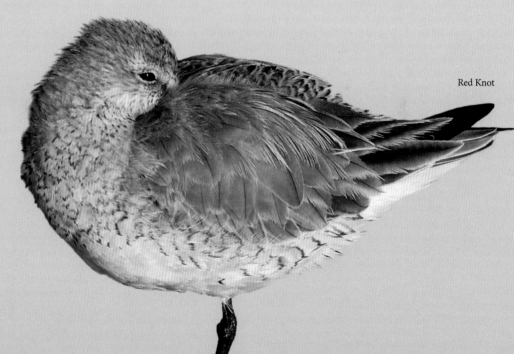

Red Knot

Tundra Swan

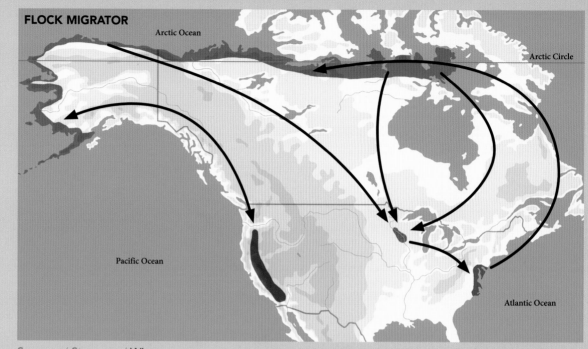

FLOCK MIGRATOR

Arctic Ocean

Arctic Circle

Pacific Ocean

Atlantic Ocean

Summer / Stopover / Winter

The Tundra Swan, formerly called the Whistling Swan, makes a different long-distance migration. One of the largest waterfowl in North America, this pure white bird with a black bill and feet nests along the coasts of Alaska and the northern reaches of Canada. In late summer, it flies in large flocks, usually in large V formations, in a southeastern direction. It makes a three- to four-day nonstop flight to several stopover areas in North Dakota and Minnesota. Some stop at Devil's Lake in North Dakota, while many more stop for upwards of three weeks along the Mississippi River in southern Minnesota. There, tens of thousands of swans feed and fatten up for the next leg of their journey.

In early November, when the backwaters of the Mississippi River are starting to freeze, the swans take off for the second leg of their journey to the East Coast. They fly another two- to three-day nonstop flight to the coast, especially the Chesapeake Bay of Maryland, where they spend the winter.

In spring, the swans take a different route back, flying up the eastern seaboard until they reach Canada. There, they turn westward and head for their breeding grounds. A small percentage will follow the fall migration route diagonally across the country back to the nesting grounds.

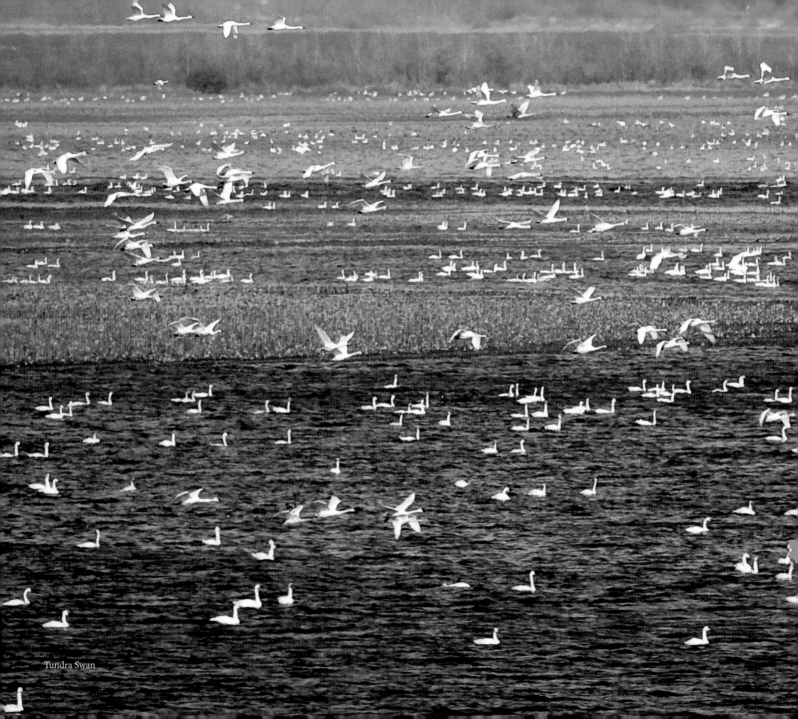

Tundra Swan

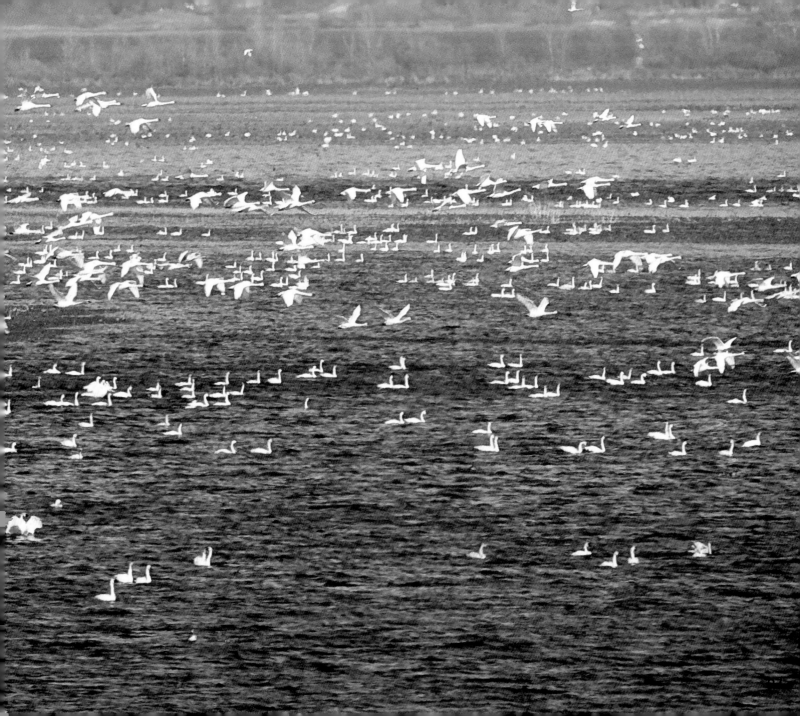

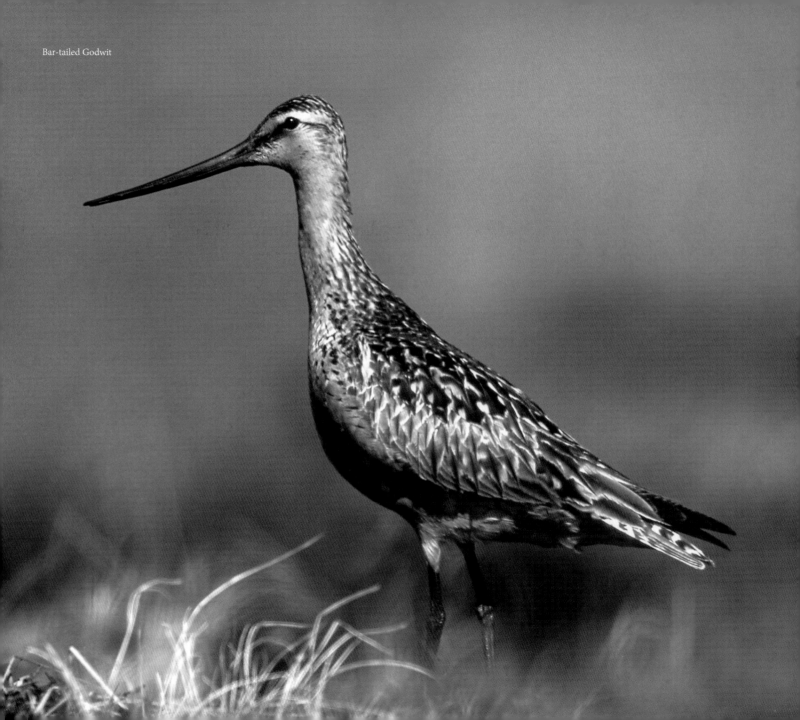

Bar-tailed Godwit

Any great migratory distance is something to be admired, but the Bar-tailed Godwit holds the record for traveling the longest distance without stopping. One of these large, long-legged shorebirds flew 7,145 miles from Alaska to New Zealand in 9 days without stopping for food, water or rest. This truly remarkable feat goes far beyond what was thought possible for any bird to accomplish. The idea of flying all the way across the Pacific Ocean in one non-stop flight is unimaginable.

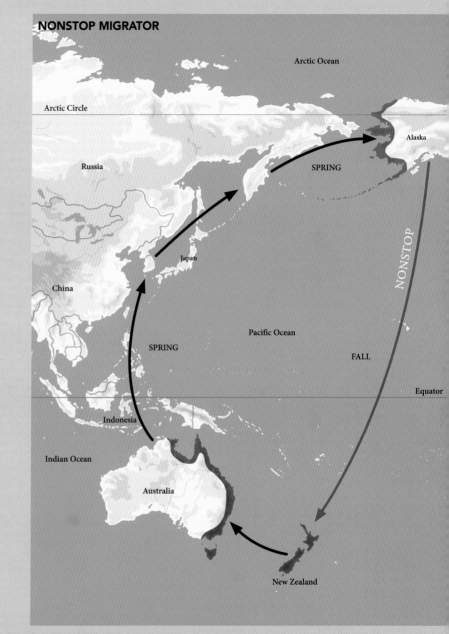

NONSTOP MIGRATOR

Summer / Winter

Arctic Tern

The record for the longest migration belongs to the Arctic Tern. This species flies an astounding 49,700 miles round-trip between the breeding grounds in the Arctic and the wintering grounds in the Antarctic. It has been calculated that over a 30-year life span, this bird will fly nearly the same distance as three trips to the moon and back!

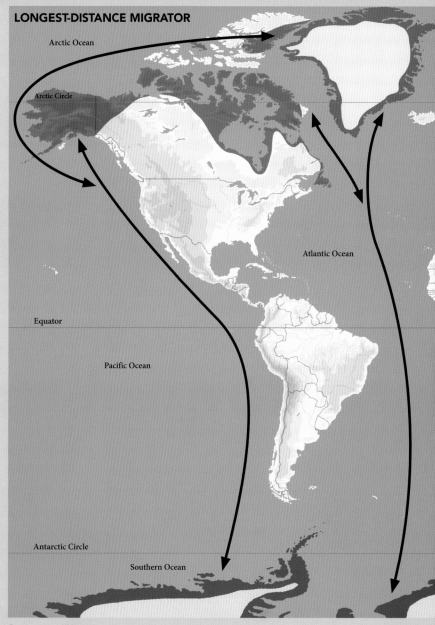

LONGEST-DISTANCE MIGRATOR

Arctic Ocean

Arctic Circle

Atlantic Ocean

Equator

Pacific Ocean

Antarctic Circle

Southern Ocean

Summer / Winter

REST STOPS
AND STOPOVERS

Many migrators fly back and forth from nearly every part of North America to tropical regions, traveling thousands of miles. Along the way, these birds face countless obstacles and dangers, both natural and man-made. Just finding enough food to fuel the trip is challenging enough.

Fat is the fuel for migration. Just how far a bird can migrate on a gram of fat depends on the size of the bird. Smaller birds, such as warblers, can fly farther on a gram of fat than larger birds, such as hawks. Blackpoll Warblers, for example, increase their weight from around 12 grams to about 20 grams. This is generally enough for them to make their flight from the Arctic regions to the tropics.

Blackpoll Warbler

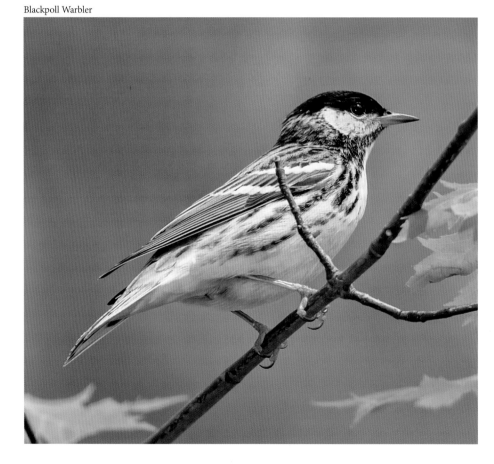

Tiny Blackburnian Warblers weigh about 13 grams and can fly around 120 miles on one gram of fat. They use one gram of fat during each night of flight, so they need to regain most of the fat lost by eating enough food during the day. Part of their migration involves making it across the Gulf of Mexico. Flying more than 600 miles nonstop takes the birds 18–20 hours and uses up 4–5 grams of fat, which can be as much as a 30 percent loss of overall weight. With a good tailwind and favorable weather, the birds can finish their flight. When there is a strong headwind or adverse weather, they use much more fat. Any individuals that run out of fat before reaching land unfortunately will perish.

Taking time to rest and feed during migration is extremely important, especially for long-distance migrators. Migratory rest stops, also called stopover sites, are natural areas that provide much needed food, water and critical shelter for migrating birds. Wildlife refuges, parks and even our backyards make good oases where migrators can rest and refuel.

Stopover length and weight gain are closely related in migrating birds. The longer a bird stays at a rest stop, the more weight it gains. Most stopovers last only about 2–3 days.

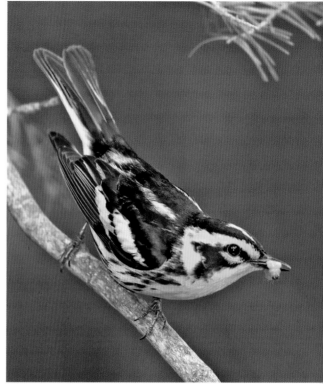

Blackburnian Warbler

Some birds will visit backyard feeders along their migration route. To study this, migrating White-crowned Sparrows at a bird feeding station in Maine were caught and banded, and observed after release. On average, the birds stayed around the feeding station for 3–4 days, eating most of the time. They gained 3–4 percent of their total body weight per day, with a total weight increase of around 10 percent over the course of their stay. This study showed that migrating birds take advantage of concentrated food sources at feeding stations, and that bird feeders can help migrators to survive.

When the weather is good during spring, most birds will bypass a stopover site and keep moving. Researchers found, however, that if weather conditions are favorable in spring and migrators are feeding at rest stops, it is likely that the birds are emaciated and starving for body fat. This explains why in some years we see lots of migrating birds at our feeders or in the woods during spring, while in other years they just zoom right through.

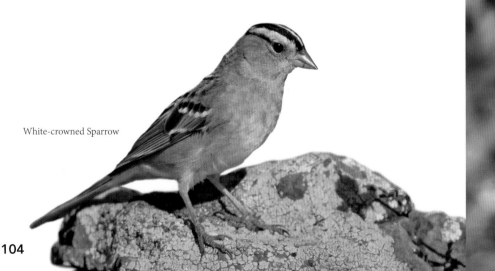

White-crowned Sparrow

Indigo Bunting (left), American Goldfinch (middle) and House Finch (right)

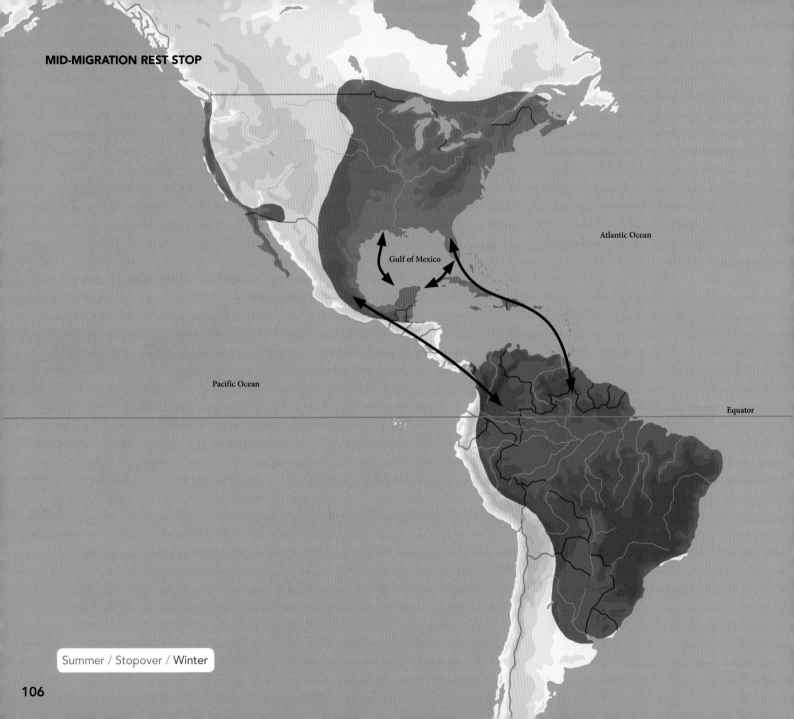

MID-MIGRATION REST STOP

Atlantic Ocean

Gulf of Mexico

Pacific Ocean

Equator

Summer / Stopover / Winter

Migratory rest stops outside of the United States are also critical for some species, such as the Purple Martin. Each fall, these swallows fly thousands of miles to spend the winter in the tropical forests of South America. Come spring, during the flight back to their breeding grounds, they take an extended stopover in Mexico. In a migration study, tiny tracking devices on the birds recorded their locations and indicated that they spent long refueling stops in the Yucatán Peninsula. Afterward, they flew nonstop successfully over the Gulf of Mexico into the United States.

Once over land, the martins continued their spring migration in an interesting leapfrog fashion, passing over the individuals that had already landed. The first birds arriving in Texas and along the Gulf Coast returned to their breeding grounds and started to nest. Martins following behind flew over them and started filling in the territory just to the north. This process continued all the way up through the breeding range as spring progressed northward. By the time the martins arrived in their northern destinations in Minnesota, Wisconsin and Canada, the birds in Texas had already hatched babies.

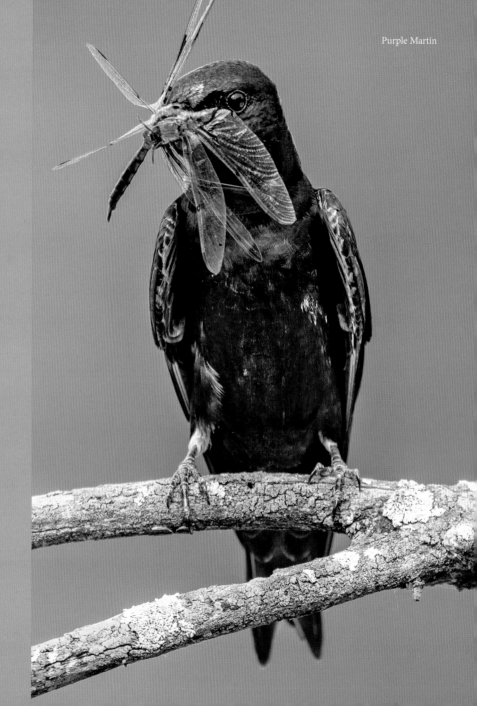

Purple Martin

REROUTING FOR WEATHER

As we have seen, not all migratory behavior fits nicely in a box. There is no single trigger that starts migration and no single navigation method that works for all species of birds. Adding to the factors that make migration so complex, the threat of an impending storm can trigger the birds to adjust their route.

In a recent study, small birds were outfitted with light-sensitive geo-trackers that recorded their locations on a given date. These devices showed that many birds left the area when a large low-pressure system and a strong storm approached. Many of these birds flew more than 300 miles away to avoid the storm and returned after the storm had passed. This study proved that birds are able to sense an oncoming change in the weather. Considering that we can't accurately predict the weather 100 percent of the time, even with our sophisticated instruments, it is amazing that birds can do this all the time, naturally.

Sandhill Crane

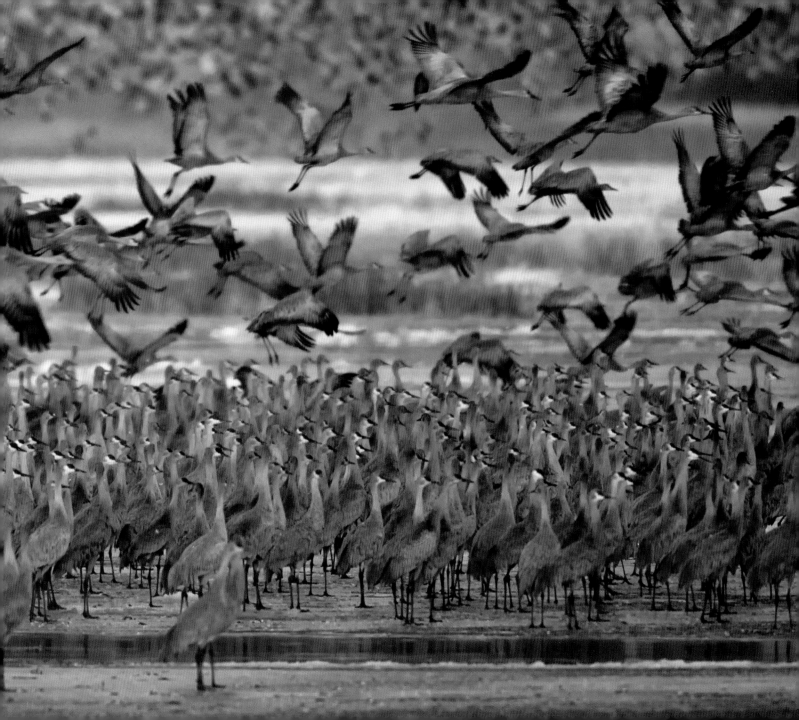

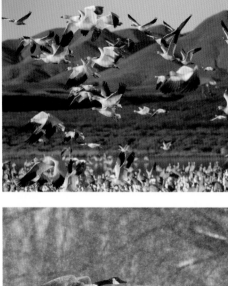
Snow Goose

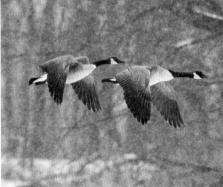
Canada Goose

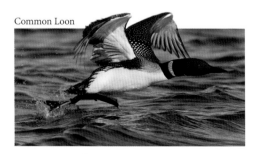
Common Loon

REVERSE MIGRATION

Sometimes we see birds migrating in a different direction than we expect during a season, such as geese in the north flying south in the spring. The migration of geese, ducks and other waterfowl is often controlled, in part, by the weather. During spring, when waterfowl are migrating northward, they sometimes end up in areas where the lakes, ponds and rivers are still frozen. This forces the birds to head back to areas with open water. To find sufficient water, entire flocks may have to fly hundreds of miles in the reverse direction.

In a study using radio telemetry, tagged Canada Geese in southern Minnesota flew 500 miles to Manitoba, Canada, during a mild winter only to find their breeding grounds still frozen. A few days later, they left and flew back to their wintering grounds in Minnesota. When they were picked up on local airport radar, their behavior seemed normal except that they were going in the wrong direction for that time of year.

I have witnessed the same thing happening to Common Loons. In spring, when loons return to their breeding grounds in central and northern Minnesota, they often encounter small lakes that are still frozen. To land and takeoff, these birds need a long expanse of open water. If they were to land on ice or dry land, they would not be able to take off. So they continue flying northward, exploring for lakes with sufficient open water. When ice still covers other lakes along the route, they will reverse their direction and fly all the way back to an ice-free lake. I've seen upwards of 100 loons resting on a lake in southern Minnesota in spring, waiting for the lakes in northern Minnesota to thaw.

OUT OF NORMAL RANGE

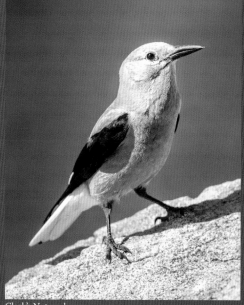
Clark's Nutcracker

Bird watchers are thrilled when a bird shows up in a region where it is normally not found. As long as the bird is not in its breeding or winter range, it doesn't matter to birders if the species is rare or common. Nutcrackers, bluebirds, flycatchers and hummingbirds are among the many kinds of birds that show up well outside of their ranges.

Birders will travel hundreds, and sometimes thousands, of miles to see one of these errant visitors. Many people assume that it takes a major event, such as a hurricane, to displace birds. But we know that other types of weather can also move birds far away from their ranges. In expectation of such an occurrence, one researcher studied continental weather maps for days before an out-of-range species arrived, and found similarities in each of the out-of-range species, perhaps showing a correlation between the weather and displaced birds. Today, researchers are able to explain the presence of both out-of-range and rare birds due to weather and storm patterns.

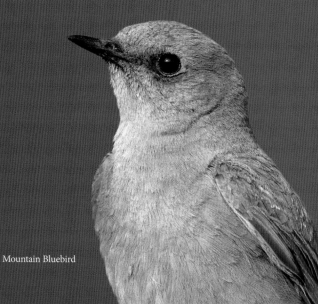
Mountain Bluebird

Not everyone, however, is convinced that weather is always the cause for displacement. Any large population of birds is likely to have a few irregular individuals. While many birds fly south for the winter, one or two may have an anomaly in their navigation systems, causing them to migrate east or west and end up in atypical places, or not migrate at all. For example, every year some errant Rufous Hummingbirds from the West show up in the eastern half of the United States during spring or fall migration. At this time it is unknown if this is an early expansion of their range or a genetic defect. Only time will tell if the Rufous will become a regular visitor to the East.

Rufous Hummingbird

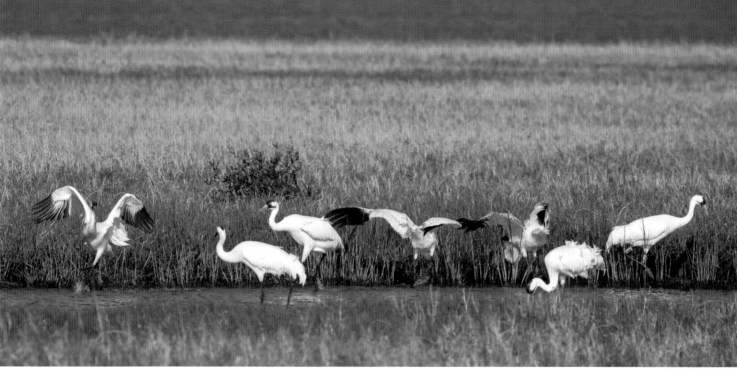

Whooping Crane

WINTERING GROUNDS

Most species migrate to established wintering sites year after year, generation after generation. They know the area and are familiar with the food resources. The endangered Whooping Crane, for instance, is very loyal to its wintering grounds. After nesting in the forests of northern Canada, each year these birds migrate to Aransas National Wildlife Refuge, near Rockport, Texas, to spend the winter. Here, they depend on the Blue Crab for their primary winter food and find a reliable source of it along the coast. I have visited this part of Texas a number of times to see these magnificent birds and find them endlessly fascinating.

Other bird species do not return to the same places every winter. For example, in a study of Herring Gulls from around the Great Lakes, the immature gulls migrated all the way to the Gulf Coast for their first winter. In each successive winter, the young were stopping their migration farther and farther north. By their fourth winter, they weren't flying any farther south than South Carolina.

Common Loon babies migrate by themselves in the fall and usually end up at the Gulf of Mexico. They tend to stay near the shoreline during winter, while the adult loons spend their time in deeper water. When the adults leave for spring migration, the juveniles remain around the Gulf. They won't become sexually active until three years of age, and most won't fly north before then. They typically return to their birthplace, but their parents will chase them out of the lake if they are still using the territory.

In other studies, songbirds were captured just before migration and fitted with radio transmitters. It was well documented that these birds normally migrate about 500 miles south to get to their wintering grounds. Researchers transported the birds in an airplane to a destination 500 miles to the south, where they were released and tracked. Although these birds are known to be loyal to their wintering grounds, they still flew about 500 miles farther south to spend the winter, indicating that they have a set distance to fly for their migration, regardless of the starting point.

This finding was not the case for other migrators in the studies. Some birds knew exactly where they needed to go after their release and modified their route to get there. It all really depended on the species.

Herring Gull

Common Loon

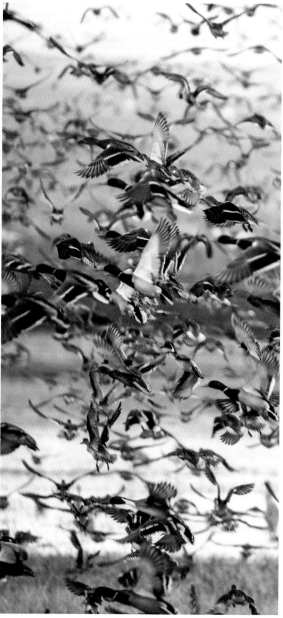

Mallard

IT'S NOT EASY

After reading this book about migration, if you are not completely in awe of these birds, then consider this: migration is one of the most difficult and death-defying things a bird can do. Bad weather can wreak havoc for a tiny migrating bird, which often weighs less than an ounce. Predators, such as hawks, falcons, bobcats and snakes, take a lot of these birds, migrating or not. And then there are man-made obstacles to avoid, such as buildings.

Today, while billions of birds migrate each spring and fall, their numbers have actually been in decline for decades. It is estimated that up to one billion birds die annually from hitting windows. Another 7 million perish after striking cell and radio towers and wind turbines. Millions more birds are killed by domestic cats. Even if you don't think your kitty is a bird killer, studies using microcameras attached to cat collars revealed that pet cats kill three times more birds and small mammals than the number of prey they bring home to your doorstep.

In addition to man-made hazards and predators, migrators are faced with habitat loss. When land development destroys large areas of natural habitat, it causes migrators to travel farther to find food, water and a place to nest. Building on patches of natural areas can impact stopover sites, fragmenting and isolating them. We can offset these detriments by supporting our state and national refuges, and state, county and city parks. These natural places are extremely important for the survival of our favorite backyard birds.

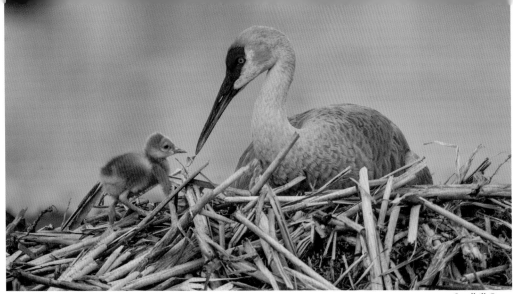
Sandhill Crane

A RHYTHM FOR LIFE

Migration is one of the major wonders of the world. Birds around the planet take part in it. It's not just a North American trait. Birds everywhere migrate. This means it must be a good adaptation that works for the benefit of birds and allows them to proliferate. If migration weren't beneficial, birds would have evolved away from it a long time ago. Even with all the dangers associated with migration and the extreme effort migration takes, migration is here to stay.

I, for one, can't imagine spring without anticipating the return of our wonderful songbirds, or being thrilled by thousands of migrating ducks and geese in the fall. Migration is a part of the rhythm of life, the ebbing and flowing of nature. It's also the dynamic part of nature, changing from year to year.

All of this adds to the growing questions about migration. While we may understand some narrow aspects of it, there is still much more that we don't know. However, I feel strongly that witnessing a migration, whether in spring or fall, connects us to the land and to nature. Just seeing a large flock of birds migrating reaches deep inside each and every one of us, and stirs our imaginations and awe of nature. And while we continue to ask questions about migration and search for the answers, the birds don't need to question it. They just simply migrate, after all.

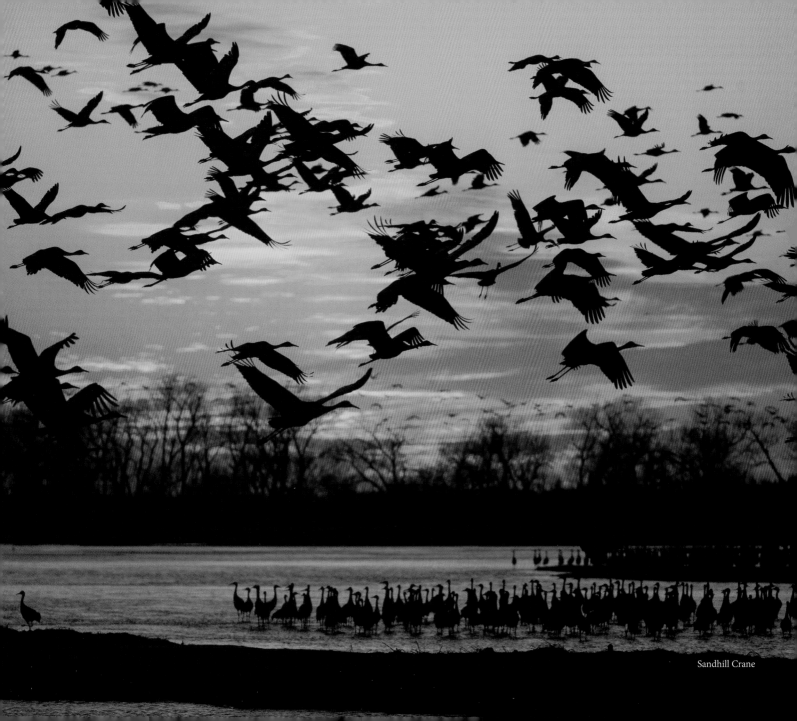

Sandhill Crane

ABOUT THE AUTHOR

Naturalist, wildlife photographer and writer Stan Tekiela is the author of the popular Wildlife Appreciation book series that includes *Wild Birds* and *Backyard Birds*. He has authored more than 175 field guides, nature books, children's books, wildlife audio CDs, puzzles and playing cards, presenting many species of birds, mammals, reptiles, amphibians, trees, wildflowers and cacti in the United States.

With a Bachelor of Science degree in Natural History from the University of Minnesota and as an active professional naturalist for more than 30 years, Stan studies and photographs wildlife throughout the United States and Canada. He has received various national and regional awards for his books and photographs. Also a well-known columnist and radio personality, his syndicated column appears in more than 25 newspapers and his wildlife programs are broadcast on a number of Midwest radio stations. Stan can be followed on Facebook and Twitter. He can be contacted via www.naturesmart.com.